D0271033

Paint a watercolour landscape in minutes

SKIES, MOUNTAINS and LAKES

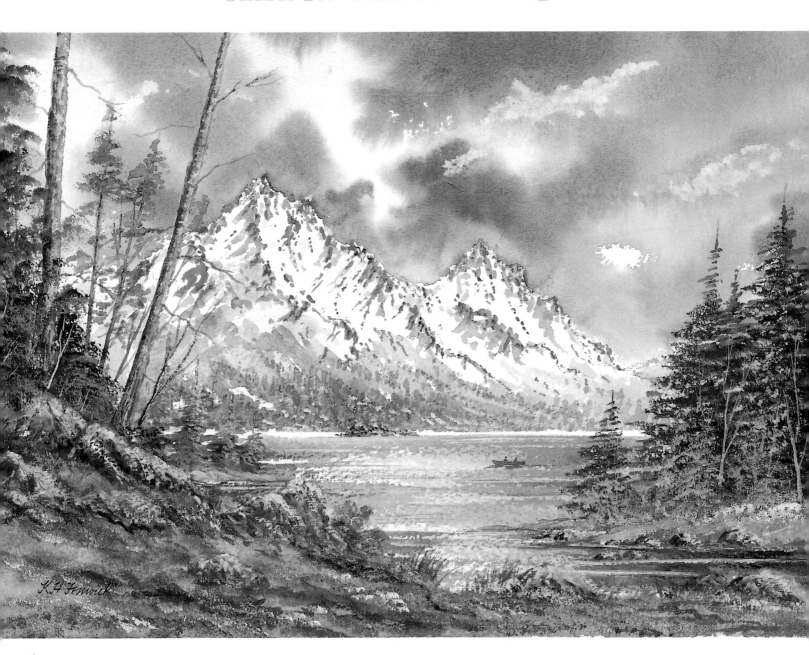

Keith Fenwick

SKIES, MOUNTAINS and LAKES

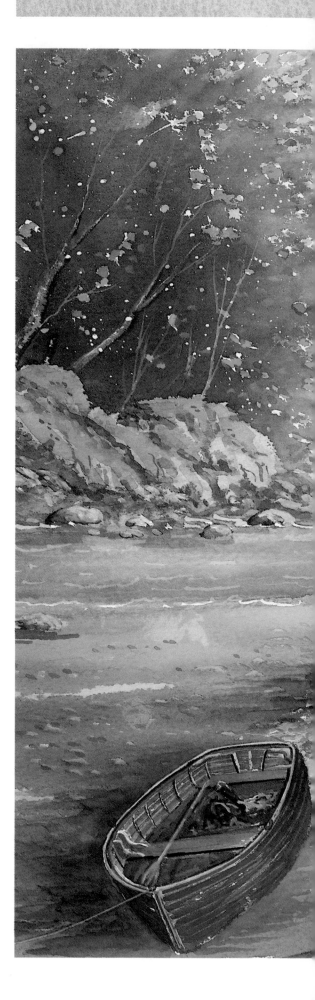

Dedication:

To Dorothy, my wife, for her support, advice and typing of the text, and to all my students over the years whose needs have helped me to determine the content of this book.

Arcturus Publishing
1–7 Shand Street, London SE1 2ES, England

Published in association with

W. Foulsham & Co. Ltd

The Publishing House, Bennetts Close, Cippenham,
Slough, Berkshire SL1 5AP

ISBN 0-572-02833-4

Copyright 2002

All rights reserved. The Copyright Act prohibits (subject to certain very limited exceptions) the making of copies of any copyright work or of a substantial part of such a work, including the making of copies by photocopying or a similar process. Written permission to make a copy or copies must therefore normally be obtained from the publisher in advance. It is advisable also to consult the publisher if in any doubt as to the legality of any copying which is to be undertaken.

Printed in China

WINSOR & NEWTON, COTMAN, FINITY, SCEPTRE GOLD, WINSOR and the GRIFFIN device are trademarks of ColArt Fine Art & Graphics Limited.

FOREWORD

The story of Winsor & Newton is one of partnership, between our founders starting in 1832 and subsequently between our company and artists. For this reason the name Winsor & Newton has become synonymous with fine art materials throughout the world. The foundation of the company stems from the development and introduction of the world's first moist watercolours in the 1830s – to this day we are justly proud of the pre-eminence around the world of our range of watercolours and materials.

Watercolour artists, from beginners to professionals, will now have the opportunity to both develop their artistic skills and their familiarity with the Winsor & Newton range through this exciting new series of techniques books, written and illustrated by the highly respected artist and instructor Keith Fenwick.

Throughout its long and successful history, the Winsor & Newton brand has developed a proud tradition of producing fine art materials of the highest quality – the company is delighted to witness the publication of a range of watercolour books that achieves similarly high levels of quality and innovation.

CONTENTS

SKIES, MOUNTAINS and LAKES

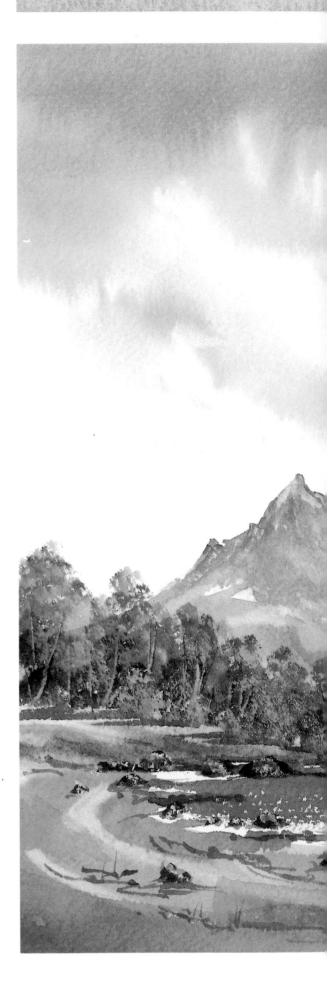

INTRODUCTION

Learning to paint will change your life – ask any artist.

Watercolour painting opens up a new world, where we become inspired by flowing washes, colour glazes, the way the paint runs and blends, the beauty and the unexpected happenings when painting wet into wet.

I have attempted to make this book as comprehensive as possible within the limitations of space. It is not my aim to try and impose a specific style of painting on you; I couldn't do that even if I tried. With practice you will develop your own style of painting. Your style will become your handwriting in paint, easily recognizable by others as being personal to yourself.

My aim is to save you twenty years of learning, by showing you the techniques, tips and useful practices I have developed over many years of painting and experimentation. I will be showing you how to identify and paint a wide range of skies, mountains and lakes; the factors to take into account and the pitfalls to avoid.

My idea of heaven is to sit by a lake surrounded by mountain scenery and paint the scene. My favourite time is in the evening when the tourists have retired to their hotels. I love to find a spot where I can't be seen, no one knows I am there, everything is peaceful, the water is calm except for the disturbance made by an occasional fish or a passing swan. What more could an artist want? Sheer heaven.

Read on and I will show you how to capture that special moment in a watercolour painting.

Happy Painting

4

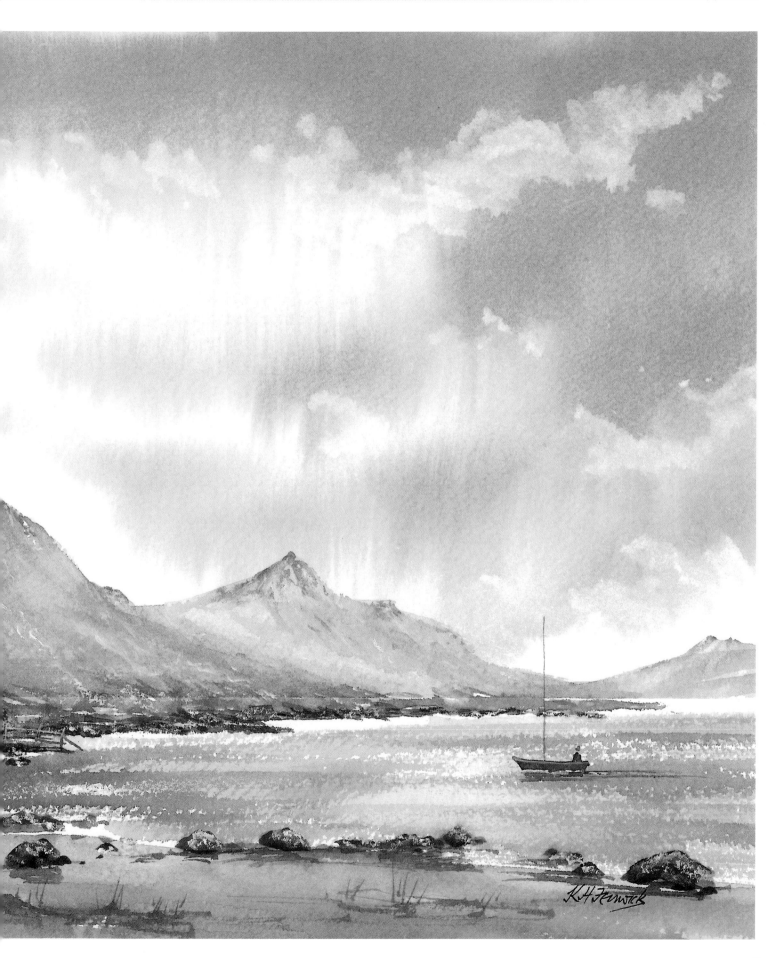

SKIES, MOUNTAINS and LAKES *Materials and equipment*

INTRODUCTION

A visit to the local art store can be a confusing experience. My preference is to use quality materials, and I would advise you to do the same. Purchase the best you can afford. It will work out cheaper in the long run and save you a great deal of frustration.

PAINTS

Most professional artists prefer tube colours because they are moist and more convenient for mixing large washes of colour. Pans of paint become very hard if left unused and release less colour.

The choice of colours is personal to the artist, but you won't go far wrong if you begin with my basic range. This comprises:

SKY	Payne's Gray
	Cerulean Blue
	Alizarin Crimson
EARTH	Raw Sienna
	Burnt Sienna
	Burnt Umber
MIXERS	Cadmium Yellow Pale
	Permanent Sap Green

My extended range includes:

SKY and WATER	French Ultramarine
	Indanthrene Blue
	Cobalt Blue
SPECIAL APPLICATIONS	Gold Ochre
	Winsor Yellow
	Winsor Red
	Purple Madder

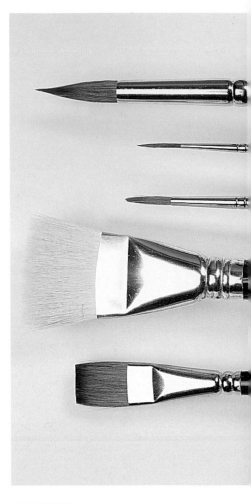

PALETTE

All artists have their own way of painting. I prefer to use a large open palette. I simply draw my colours into the centre of the palette and mix them to my requirements. For large washes I premix colours in saucers. The palette shown includes a lid which provides more than ample space for mixing colours.

BRUSHES

For painting skies and other large areas, I use a 1½in hake brush and for control a size 14 round. For buildings and angular elements, such as mountains and rocks, I use a ¾in flat. For fine detail, such as tree structures, I use a size 3 rigger (originally developed for painting ships' rigging, hence the name), and for detailed work (shadows etc) I use a size 6 round.

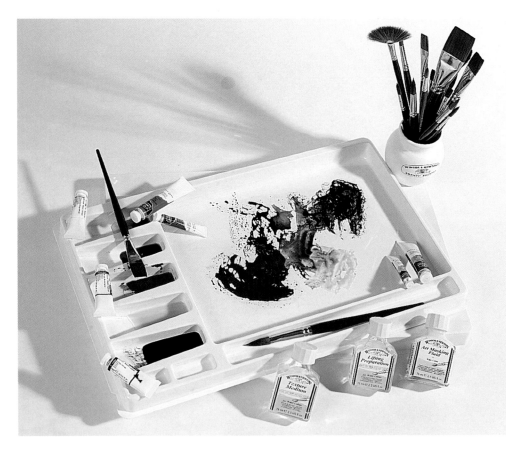

PAPERS

Quality papers come in different forms, sizes, textures and weights. Paper can also be purchased in gummed pads, spiral bound pads, blocks (glued all around except for an area where the sheets can be separated) and in varying sizes and textures.

I prefer to purchase my paper in sheet form (30in x 22in) and cut it to the appropriate size. The paintings in this book were painted on 200 or 300lb rough textured watercolour paper. When sketching outdoors, I use spiral bound pads.

Winsor & Newton offer a choice of surfaces and weights, as follows:

HP (Hot pressed) has a smooth surface, used for calligraphy and pen and wash.

NOT (Cold pressed) has a slight texture (called 'the tooth') and is used for traditional watercolour paintings.

ROUGH paper has a more pronounced texture which is wonderful for large washes, tree foliage, sparkle on water, dry brush techniques, etc. I always use a rough textured paper.

Paper can be purchased in different imperial weights (the weight of a ream [500 sheets], size 30in x 22in):

90lb/190gsm is thin and light; unless wetted and stretched, it cockles very easily when washes are applied.

140lb/300gsm paper doesn't need stretching unless very heavy washes are applied.

200lb/425gsm or 300lb/640gsm papers are my preference.

OTHER ITEMS

The following items make up my painting kit:

Tissues: For creating skies, applying textures and cleaning palettes.

Mediums: Art Masking Fluid, Permanent Masking Medium, Granulation Medium and Lifting Preparation are all useful and selectively used in my paintings.

Masking tape: To control the flow of paint, masking areas in the painting and for fastening paper to backing board. I prefer ¾in width as it is easier to remove.

Cocktail sticks: Useful for applying masking when fine lines are required.

Grease-proof paper: For applying masking.

Atomizer bottle: For spraying paper with clean water or paint.

Painting board: Your board should be 2 inches larger all round than the size of your watercolour painting. Always secure your paper at each corner and each side (8 places) to prevent it cockling when you are painting.

Eraser: A putty eraser is ideal for removing masking.

Sponge: Natural sponges are useful for removing colour and creating tree foliage, texture on rocks, etc.

Water-soluble crayons: For drawing outlines, correcting mistakes and adding highlights.

Palette knife: For moving paint around on the paper (see page 32).

Saucers: For mixing large washes and pouring paint.

Hairdryer: For drying paint between stages.

Easel and stool: I occasionally use a lightweight easel and a stool for outdoor work.

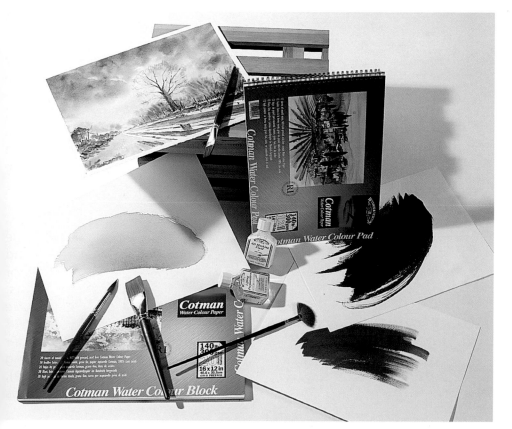

PAINTING SKIES *Introduction*

Skies are exciting to paint and they take so little time – less than three minutes. They establish the atmosphere and mood of the painting and, as they can represent up to two-thirds of a painting, it's important to paint them well.

As the weather changes, the sky influences the colours in the landscape. A pale blue sky drenched in sunshine makes the landscape sparkle. When the blue changes to grey, indicating an app-roaching storm, the landscape colours become dull and moody. A full blown storm creates a sense of fear and awe.

Sometimes there will be no clouds in the sky on the day you have chosen to work outdoors. It's not unusual for me to create an interesting sky to complement my landscape. If nature's perfect, copy it; if it's not, use artistic licence to improve it. Be creative, use your imagination.

Often I will paint the landscape and then paint in the sky to fit it. Acrylic watercolours are particularly useful in this instance, because if the sky colour runs over my under-painting the colour can't be lifted. A big advantage.

In this part of the book my aim is to show you how to paint a wide variety of interesting skies. Skies aren't difficult to paint, but they must be painted quickly. No two artists are ever going to be able to paint identical skies because of the speed at which they have to be painted to avoid hard edges forming – but that's what is so exciting about watercolour painting.

I hope the examples in this book will inspire you. Constant practice will boost your confidence until the painting of skies becomes second nature.

You will call on a range of colours to paint skies. Here are the ones I find most useful:

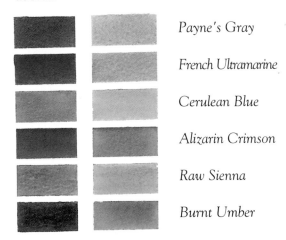

Payne's Gray

French Ultramarine

Cerulean Blue

Alizarin Crimson

Raw Sienna

Burnt Umber

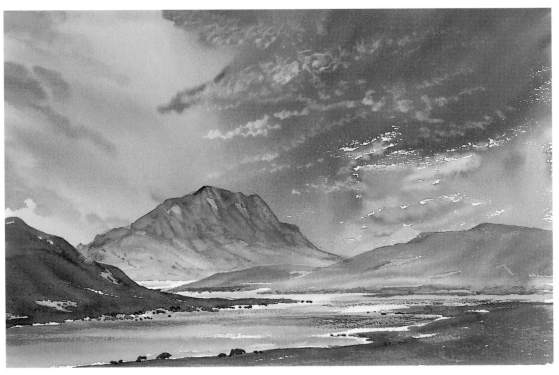

In this sketch I used a very simple technique, creating the cirrus sky by removing paint with an absorbent tissue.

Which cloud?

To identify clouds think descriptively. You might describe the four basic cloud types in these terms:

CIRRUS: hair-like or feathery
CUMULUS: balls of cotton wool
NIMBUS: dark rain-bearing clouds
STRATUS: clouds in layers

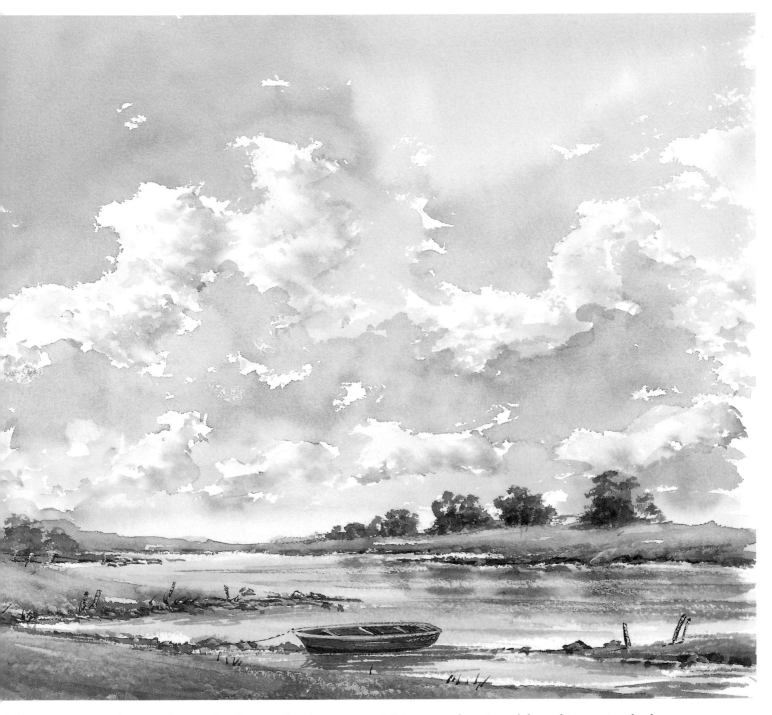

This painting provides a good example of a cumulus sky; see page 15 for an explanation of the techniques involved.

TYPES OF CLOUD

More important than being able to identify clouds is to be able to represent them realistically. Observation is important if you are going to make them look real. Let's look at a few of the basic types in more detail:

Cirrus clouds appear as wispy streaks high up in the sky.

Cumulus clouds are soft and fluffy, like balls of cotton wool floating in the sky. They appear larger at the top and smaller at the bottom (in the distance –

perspective). Cumulus clouds display shadows and on a sunny day their tops sparkle with a soft yellow. Their base is usually flat.

Nimbus clouds tell us that a storm is imminent. Dark and rain-bearing, they can fill us with a sense of awe or foreboding.

Stratus clouds, as the name suggests, form in almost horizontal layers across the sky.

PAINTING SKIES *Timing*

The sky can represent up to two-thirds of your painting, creating the atmosphere and mood of the landscape. It therefore goes without saying that the ability to paint an interesting sky is important. It's not possible, however, or necessary, to expect to represent the sky exactly – you can't be expected to compete with nature. As artists, our challenge is to paint a believable representation.

Timing is paramount when painting skies. Hard edges, cauliflowers, whatever you want to call them, occur when wet paint is applied over an under-painting that is more than one-third dry. Each successive layer of paint should be stiffer (less wet) than the under-painting. Practise until you've managed to paint a sky in under three minutes without hard edges forming.

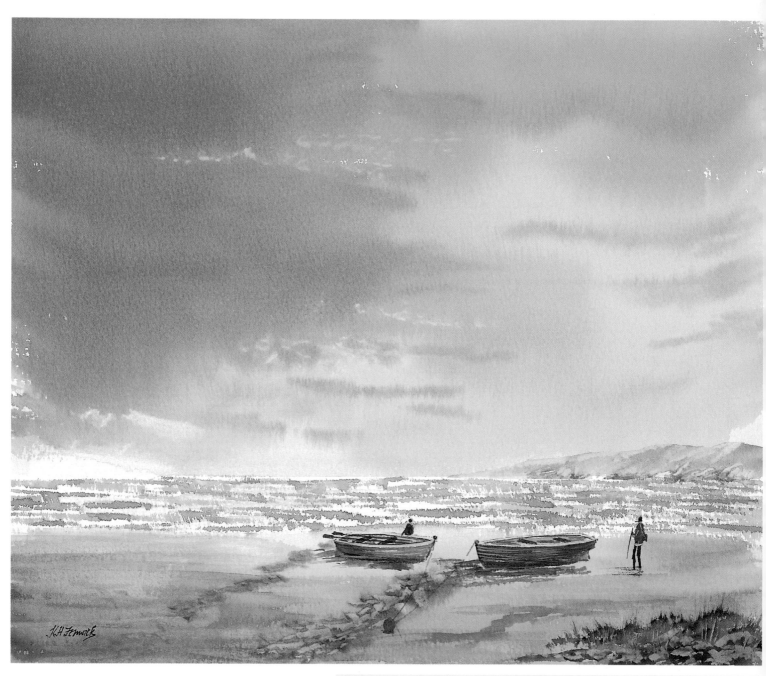

This soft sky was painted by initially applying a Raw Sienna wash. The clouds were painted with broad strokes of the 1½ in hake brush loaded with a Payne's Gray/Cerulean Blue mix. I used a tissue to create a few wispy white clouds.

Painting clouds
When you're painting in clouds, it's a good idea to leave about 50 per cent of your under-painting uncovered.

AVOIDING HARD EDGES

The reason for the formation of hard edges is that wet paint is applied over an under-painting that is more than one-third dry. A simple experiment will show you what an unpleasant effect this creates.

Try it for yourself. Paint in any dark colour, let it partially dry, drop a splash of water in the middle and watch the hard edges form.

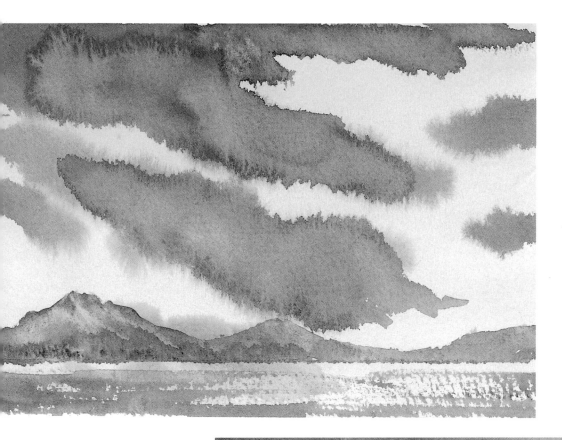

The picture shown left is typical of that produced by beginners to watercolour painting who haven't yet mastered the timing. Two things have happened here. Wet paint has been applied over an under-painting that was about half dry, creating the unwanted feather-like hard edges, and the cloud edges haven't softened and been able to blend into the drier under-painting. The result is a messy muddy looking, un-attractive sky. Compare this with the effect achieved in the painting below.

Here the cloud formations were painted when the shine had gone off the under-painting, resulting in a soft, fresh looking, wet into wet sky. To achieve this effect, your sky must be painted in under three minutes.

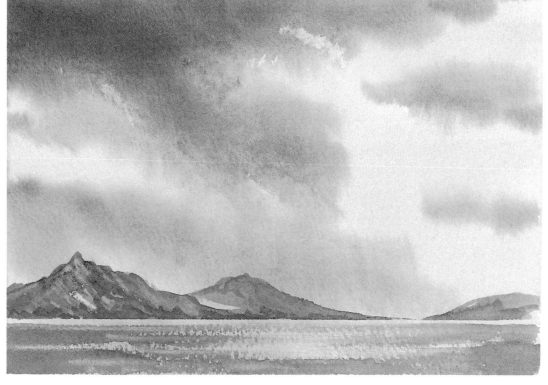

Each type of sky provides us with an interesting roof to our painting and creates the atmosphere and mood. These will in turn determine the colours and tones we use to paint them.

The colours and mixes shown here are those I most commonly use when painting skies. There may be occasions when I require a particular depth of colour or subtle tone, and in these circumstances I may select additional colours.

Indanthrene Blue mixed with Payne's Gray, for example, produces a deep rich blue. Purple Madder is useful when painting evening skies. I find Raw Sienna invaluable as an initial wash over the paper. It adds warmth to the sky, but apply it as a very pale wash. There is a vast range of colour available, so why not try them.

BRUSHWORK

Use a light touch with a large brush, and the minimum number of brush strokes. If you brush over the under painting more than is necessary, your sky will look muddy.

The 1½in hake brush is ideal for painting skies. Familiarize yourself with it by using it for the projects on the facing page. Apply bold sweeping strokes with your arm rather than using a wrist action.

To achieve the correct balance of colour you will need to experiment with mixing colours. The mixes shown right are just some of the variations possible using the colours shown below left.

The colours shown below right are mixes useful for clouds and varying strengths of Raw Sienna for under-painting.

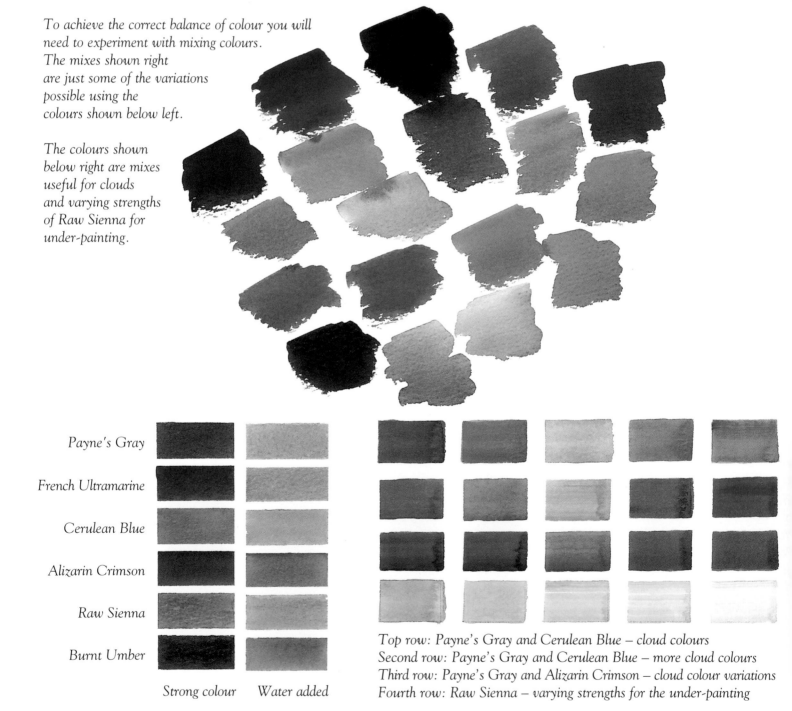

Payne's Gray

French Ultramarine

Cerulean Blue

Alizarin Crimson

Raw Sienna

Burnt Umber

Strong colour Water added

Top row: Payne's Gray and Cerulean Blue – cloud colours
Second row: Payne's Gray and Cerulean Blue – more cloud colours
Third row: Payne's Gray and Alizarin Crimson – cloud colour variations
Fourth row: Raw Sienna – varying strengths for the under-painting

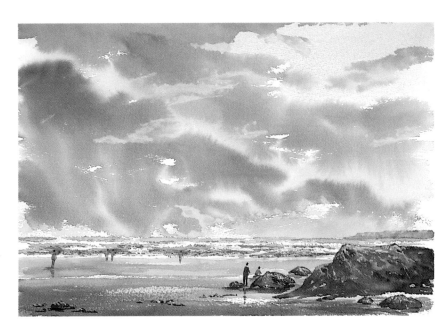

used a 1½ in hake brush to paint this atmospheric sky, applying a weak Raw Sienna wash to the whole of the sky area and quickly washing in some Cerulean Blue at the top right and a weak Alizarin Crimson in selected areas. When the shine had gone from the paper surface (less than one-third dry), I painted in the dark clouds using strong mixes of Payne's Gray/Alizarin Crimson.

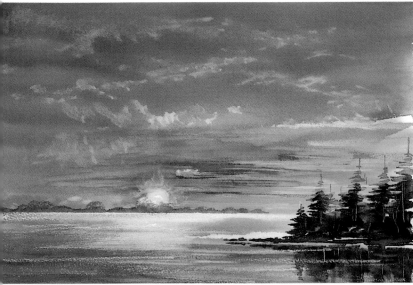

For this evening sky, initially I painted Raw Sienna above the horizon line and added some Alizarin Crimson, then immediately I painted the blue sky by brushing in a strong wash of a Payne's Gray/French Ultramarine mix, allowing the paint to run down and blend with the Raw Sienna/Alizarin Crimson washes. A soft tissue was used to remove paint to create the white feathery clouds. A little Cadmium Yellow Pale was used to paint the setting sun.

You'll enjoy painting this sunset using the 1½ in hake brush. Initially I applied a Raw Sienna wash to the whole of the sky area and painted in some Cerulean Blue at the top right. The dark clouds were painted using a Payne's Gray/Alizarin Crimson mix, leaving about half of the under-painting showing through.

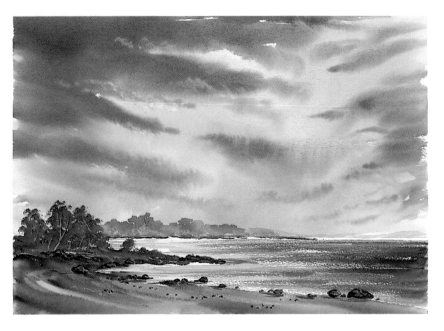

PAINTING SKIES *Techniques*

Once you have mastered the brush strokes and timing, you will really enjoy painting skies.

All skies are painted wet into wet. This means that you paint wet paint into a wet under-painting. We have already seen how tricky this can be, so always apply the basic principles discussed previously to avoid hard edges. The hake brush is traditionally used for painting skies. I prefer one that has soft hair (goat hair) and is 1½ in wide. The secret when painting skies is to wet your paper initially with clean water or a weak raw sienna. You can apply your wash quickly with sweeping strokes, using arm rather than wrist movements.

Once I see the shine going off the paper I paint in my cloud structures, using a light touch of the hake. Don't brush over the paint too many times. The fewer brush strokes you use, the fresher your sky will look.

Your board should be angled at approximately 15 degrees, just sufficient to allow the paint to run slowly down the paper. Timing comes with experience, so you will need to practise painting lots of skies – after all they only take three minutes.

The right look

Don't forget, when using watercolours – if it looks right when it's wet, it's wrong! As the paint dries you can lose up to 30 per cent of tonal value, so you must paint with darker tones to allow for this.

I observe this kind of sky most evenings when I look out of my window. I painted a Cadmium Yellow Pale wash, adding Raw Sienna and Alizarin Crimson to produce a variegated under-painting.

The clouds were painted using various strengths of Payne's Gray/Alizarin Crimson mixes. I wanted some of the cloud edges to be soft and the larger clouds at the top to have harder edges. Timing was important here.

Cadmium Yellow Pale

Raw Sienna

Alizarin Crimson

Payne's Gray

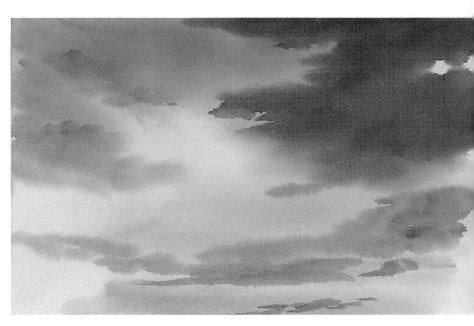

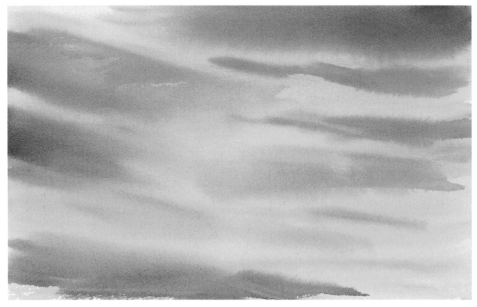

Raw Sienna

Payne's Gray

Cerulean Blue

This cirrus type sky was painted in less than two minutes by applying a very pale Raw Sienna wash to cover the whole of the sky area.

Using broad sweeps of the hake, I painted in the darker Cerulean Blue/Payne's Gray clouds. This type of sky is very easy to paint in less than two minutes.

I could not resist painting this lovely early morning sky. Initially I painted the usual Raw Sienna wash, then added some Alizarin Crimson as I worked downwards.

When the painting was approximately one-third dry, I used a strong Payne's Gray/Alizarin Crimson mix for the cloud formations. A tissue was used to create a few soft white clouds.

Raw Sienna

Payne's Gray

Alizarin Crimson

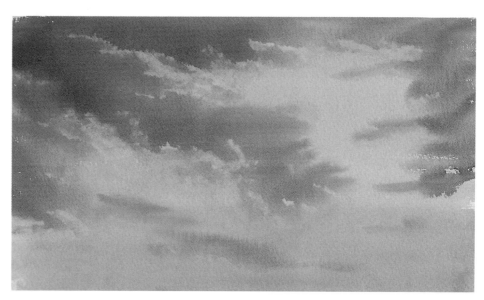

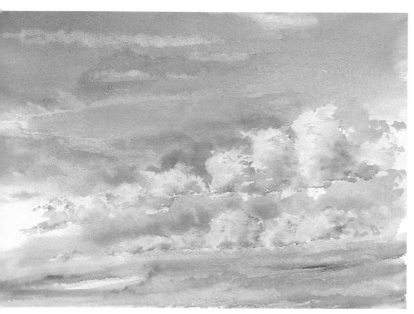

Raw Sienna

French Ultramarine

Payne's Gray

Alizarin Crimson

Cumulus clouds are like balls of cotton wool floating in the sky. The easiest way to represent them is initially to paint your under-painting using Ultramarine Blue/Payne's Gray mixes, adding darker tones here and there for variation and while still wet, to create the cloud shapes by blotting out using absorbent tissues.

Wet a few of the white clouds at a time with clean water and drop in deeper values of sky colours plus Alizarin Crimson to represent shadows. If it's a sunny day, add a little Raw Sienna to the tops of the clouds to create sparkle.

This soft evening sky was created by initially painting a Cadmium Yellow Pale wash and adding patches of Cerulean Blue, Raw Sienna and Alizarin Crimson. A mixture of Alizarin Crimson and Payne's Gray was used to paint the clouds. The soft edges to the clouds were achieved by painting them when the under-painting was quite wet. It's a matter of timing. Subtlety is what is required here, so don't use garish colours.

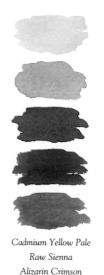

Cadmium Yellow Pale

Raw Sienna

Alizarin Crimson

Payne's Gray

Cerulean Blue

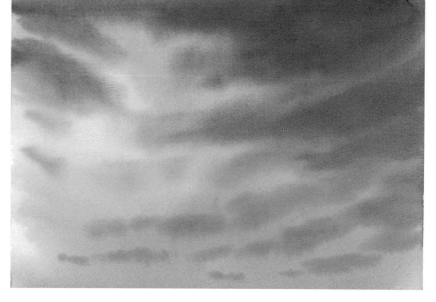

This is a fine example of an atmospheric sky. Various techniques were used to create the effect of an approaching storm. The clouds have cast shadows over the land and it's time to seek shelter. There are no bright blues in this sky. The clouds were painted with mixes of Payne's Gray/Cerulean Blue, with a little Alizarin Crimson added to achieve variation, over a wet pale Raw Sienna under-painting. I used a 1½ in hake brush and a minimum of strokes, lightly dancing it across the surface of the 140lb paper.

The whole sky was painted wet into wet in less than three minutes. It's important that the clouds are painted in while the painting is no more than one-third dry, to avoid the occurrence of hard edges (see page 11 for more on this).

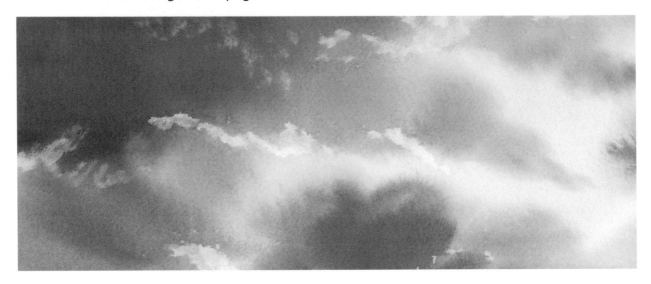

CLOUD FORMATION

The cloud formation, which is probably the most important part of this painting, represents the approaching storm and has therefore been painted in a slightly darker tonal value. The clouds were painted using circular motions with the corner of the hake brush.

The Raw Sienna under-painting was no more than one-third dry when I painted in the clouds, allowing the cloud edges to soften and creating a natural effect. You'll notice that I've separated the cloud formations by leaving a small light area. A simple touch like this can achieve a pleasing effect.

DETAILS OF HOUSE

The clouds have not been painted right up to the farmhouse, ensuring counter-change (light against dark, dark against light) between the building and the sky area. This is important, as it makes the buildings and trees behind them stand out against the sky. Note the inclusion of a few sheep and the smoke from the chimney, adding life to the finished painting. The sky shadows have been washed across the foreground.

CREATING LIGHT AREAS

To create light areas and realistic cloud formations an absorbent tissue was used to remove colour. A gentle dabbing action was used, turning the tissue to absorb colour and reveal the white of the paper. This technique must be used while the sky area is still wet. It's a simple technique, one I often use to create interesting cloud structures.

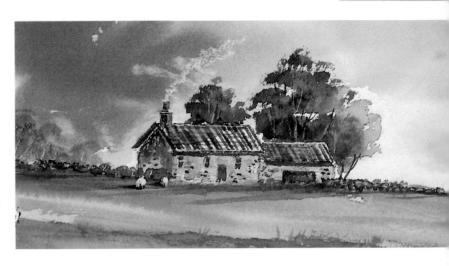

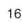

ADDING INTEREST

The addition of a small splash of another colour can provide a more pleasing sky structure.

You'll notice that I have added a touch of Alizarin Crimson here, to give the picture warmth and variation.

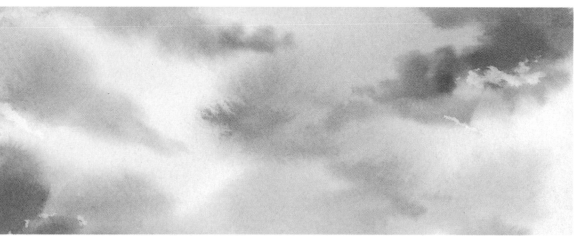

PAINTING SKIES *Project*

Evening Splendour is an ideal painting for the less experienced painter to attempt. It also provides me with the opportunity to introduce you to the concept of glazing. A glaze is produced by mixing a little paint with a lot of water to make a pale-coloured wash.

Glazes can be applied using a traditional watercolour, but an acrylic watercolour has the advantage of allowing several subtle glazes to be applied without the risk of the under-painting lifting.

1. THE SKY AND BUSHES

I positioned masking tape unevenly across the painting to represent the horizon. The sky was painted using a 1½ in hake brush loaded with a weak raw sienna wash, followed by Payne's Gray/Alizarin Crimson mixes for the clouds. Tissues were used to create the cloud shapes.

The bushes were painted using the cloud colours. When these were dry, I applied a little white acrylic to add snow to the foliage which I stippled with a round ended hog-hair brush. When I painted the fence I made sure that the distance between the posts was twice the height of the fence.

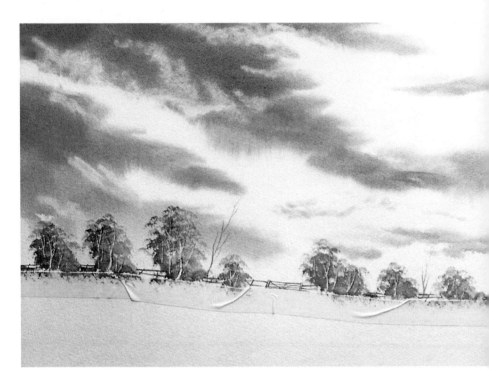

2. THE FOREGROUND

The masking tape was slowly removed and the foreground painted by using a stippling action with the hake brush, lightly dancing across the paper to shape the track and represent stubble in the snow. Light sweeps of the hake were applied in the foreground to provide a dry brush effect.

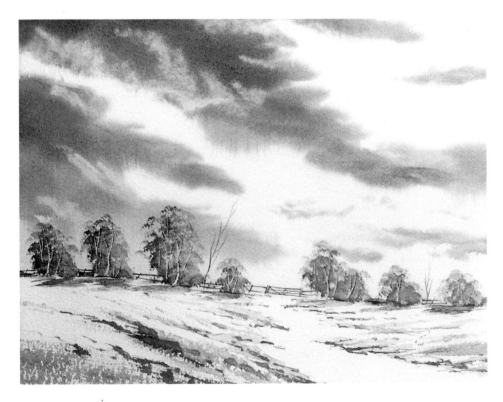

These are the colours you will need

Payne's Gray

Alizarin Crimson

Raw Sienna

White

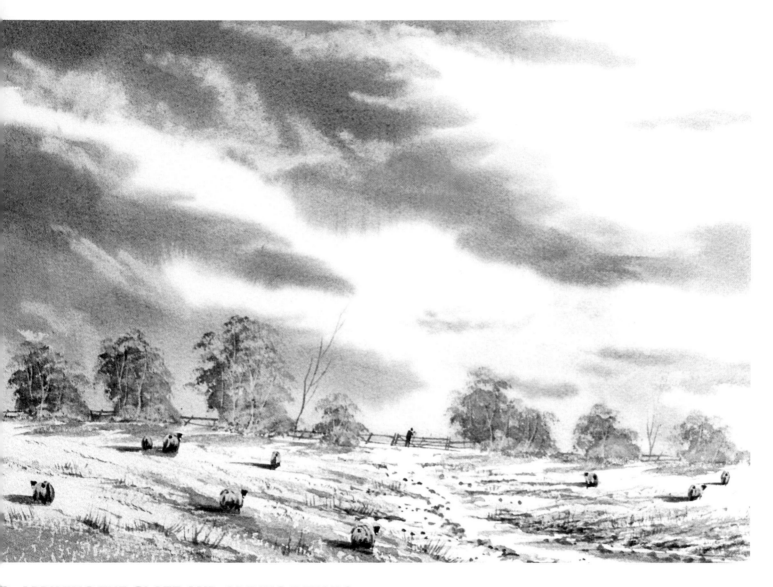

3. APPLYING THE GLAZE AND ADDING DETAILS

I love snow scenes but they don't have to look cold. I added some warmth to this painting by applying a Raw Sienna glaze over the whole of the sky and adding a little Alizarin Crimson nearer the horizon.

The glaze was mixed in a ceramic saucer and applied with a 1½ in hake brush, working from top to bottom.

I transferred some of the sky glaze to selected areas in the snow to achieve a balance of colour in the painting. When the paint was dry, I felt the addition of a few sheep and a shepherd leaning over the gate would enhance the scene. Detail was added to the track using a rigger brush.

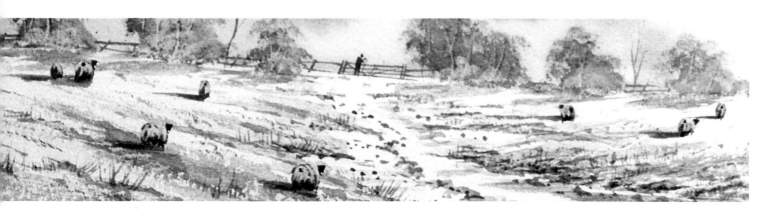

PAINTING SKIES *Project*

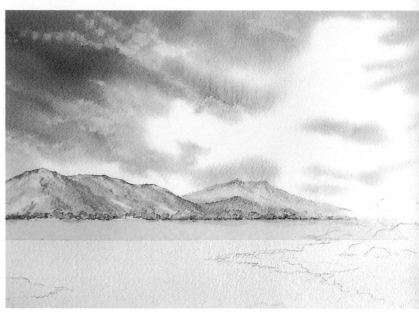

1. SKY AND MOUNTAINS

An outline drawing was completed using a dark brown water-soluble crayon. A piece of ³/₄ in masking tape was positioned across the paper to represent the water line. The sky was painted with the usual initial Raw Sienna wash. The clouds were painted using mixtures of French Ultramarine/Payne's Gray. Tissues were used to soften the cloud formations.

The distant mountains were painted with directional strokes of the hake, using a Raw Sienna under-painting. While this was still wet I brushed in various tones of green. An Alizarin Crimson/Payne's Gray mix was used to paint in the far distant mountains. Impressions of trees at the water's edge were painted with a size 6 brush and a few buildings added.

2. MASKING AND FOREGROUND

When dry, the tape was slowly removed. The boat was drawn on a piece of 1¹/₂ in masking tape, cut to shape with a pair of scissors and positioned on the painting to mask the area where the boat was to be placed. The grass areas were painted, working around the right-hand rocky outcrop and a few smaller rocks added.

3. ROCKS AND WATER

The rocky outcrop on the right was painted by applying a Raw Sienna wash and painting in Burnt Sienna and Payne's Gray/Alizarin Crimson mixes. When approximately one-third dry, I used a palette knife to scrape in the rock structures.

The water was painted using the sky colours. I used the side of a size 14 round brush lightly to create sparkle on the water. A few additional rocks were painted on the shore and then the masking tape representing the boat was removed.

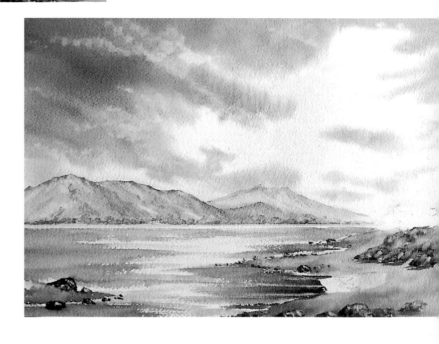

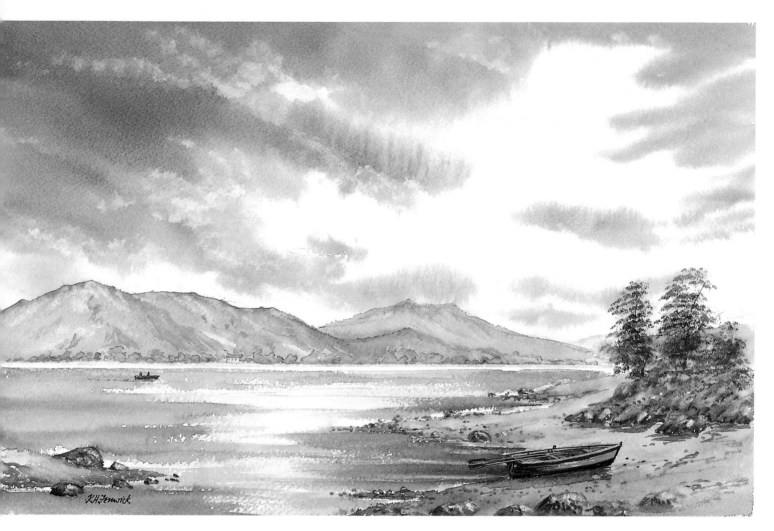

4. TREES AND BOATS

I painted in the trees and then the green boat to create interest in the foreground. Using a pre-softened white water-soluble crayon, I added a little sparkle here and there to the rocks.

Finally, the distant fishing boat was simply painted using a rigger brush. Raw Sienna washes were applied to the water to reflect the sky and over parts of the foreground to add warmth to the painting.

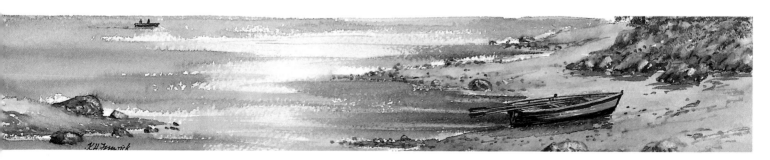

These are the colours you will need

Payne's Gray

Alizarin Crimson

Raw Sienna

French Ultramarine

Burnt Sienna

PAINTING SKIES *Using speciality mediums*

Here I want to introduce you to some speciality mediums that I find exciting to use. Do try them where appropriate. You will find them a useful addition to your range of materials.

GRANULATION medium was introduced to provide a granular appearance to colours that normally gave a smooth wash. For maximum effect, if you dilute your colour with medium alone you can achieve a variety of results. I find this medium useful for painting skies or where a light texture effect is required.

PERMANENT MASKING medium is a non-removable transparent liquid mask which can be applied directly to your paper, or mixed with colour and applied to achieve a one-stop mask. It also washes out of brushes very easily by simply rinsing in water; traditional art masking fluid, by contrast, can be difficult to remove from brushes.

Unlike traditional art masking fluid, which has to be applied, dried, painted over, removed and then your element painted in colour, with permanent masking you paint your element in colour, and once it is dry you can over-paint, the masking repelling the wash.

I have used permanent masking to create texture on

In the painting on the right I've used the granulation medium for the sky and permanent masking medium for the tree foliage. For the foliage, I applied the masking with crumpled tissue and over-painted to create the texture.

rocks, foregrounds, foliage etc. Experimenting with this medium has shown me that it works best with light washes. When these are dry, thicker paint can then be applied over the masking to add details.

TEXTURE medium produces a textured finish for watercolours. It can be applied directly to the paper and when dry over-painted or mixed with watercolour and then applied.

LIFTING medium enables the removal of paint at a later stage. Some colours are staining colours and difficult to remove. By applying the lifting medium first, the colour can be easily removed.

BLENDING medium slows drying, providing that extra time sometimes needed when painting in hotter climates. For maximum blending time, dilute your colour with medium alone. Diluting with water will provide a variety of drying times.

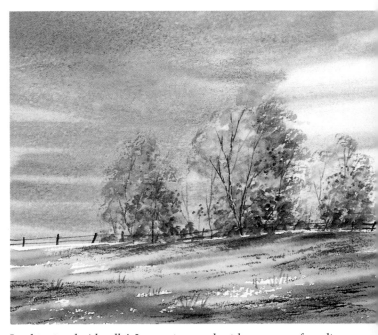

In this simple 'doodle' I experimented with a range of mediums.

In the painting on the left I used lifting medium for the sun and over-painted with a Cadmium Yellow wash. When dry, I teased the colour away from the centre by gently rubbing with a small bristle brush and dabbing with a tissue.

To paint the sky, I applied a Cadmium Yellow wash and added some Raw Sienna and Alizarin Crimson as I progressed down to the horizon. The sky colours were transferred into the water. When dry, I added the darker clouds using a mix of Payne's Gray/Alizarin Crimson/Burnt Umber.

Although there is a lot of colour in this sky, it still looks subtle and warm. Don't make your sunsets too bright and overpowering.

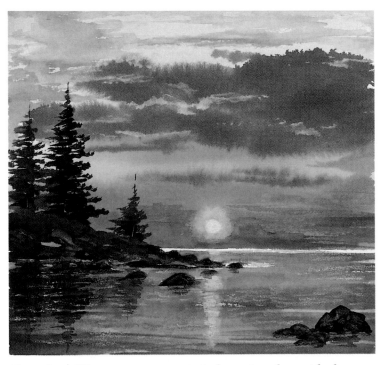

Evening Glow *represents a typical evening sky, with the sun going down across the lake.*

The sky was painted by spattering permanent masking, allowing it to dry, then over-painting the sky with blue mixed with granulation medium. The result was the effect of falling snow. Lifting medium was initially painted over the areas filled with fir trees.

I used white paint mixed with texture medium to add the snow to the trees and when this was dry I washed away some colour between the trees. Having previously applied the lifting medium, I was able to lighten these areas. The rocks were formed by using a palette knife.

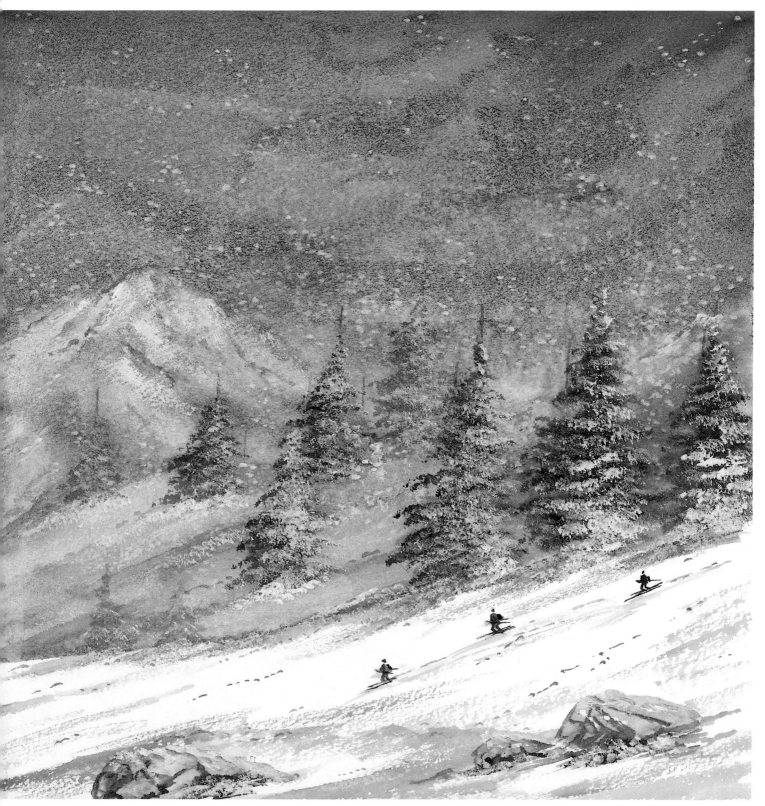

Ski Patrol was an experimental painting I completed to test the appropriate use of the speciality mediums.

PAINTING SKIES *Further techniques*

My aim here is to introduce you to further techniques to enable you to create interesting skies. As the sky can cover two-thirds of your painting, it's important that you practise these techniques to achieve a realistic impression. Glazes can be applied to selected areas in a painting or to the painting as a whole to harmonize the colours, as each colour in the painting will be tinted by the same glaze.

APPLYING A GLAZE

With this scene I applied a warm Raw Sienna wash and added a touch of Alizarin Crimson to selected areas.

Medium tones of Payne's Gray/Alizarin Crimson/Burnt Umber were used to paint the clouds. I used a tissue to create structure in the clouds. When the paint was dry, I mixed a Raw Sienna glaze and, using the hake brush, washed over the whole of the sky area to give it added warmth and glow.

A glaze is a small amount of colour mixed with lots of water.

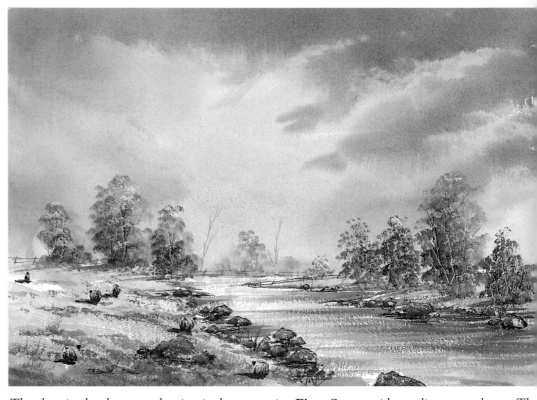

*The glow in the sky was what inspired me to paint **First Snow** with acrylic watercolours. The beauty of acrylics is that if you become bored with a painting, you can apply glazes to change it*

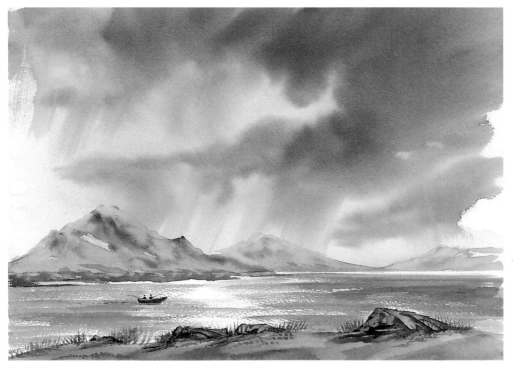

RAIN CLOUDS

Here I applied an initial wet wash of very pale Raw Sienna and quickly painted the dark nimbus clouds with a Payne's Gray/Cerulean Blue mix.

I tilted my watercolour pad until it was almost vertical, allowing the paint to run to represent the shafts of rain. When the paint had run sufficiently, I laid the pad flat and used a tissue to soften the tops of the mountains.

Rain Clouds. *There's not much colour in this study. I painted it as I saw it.*

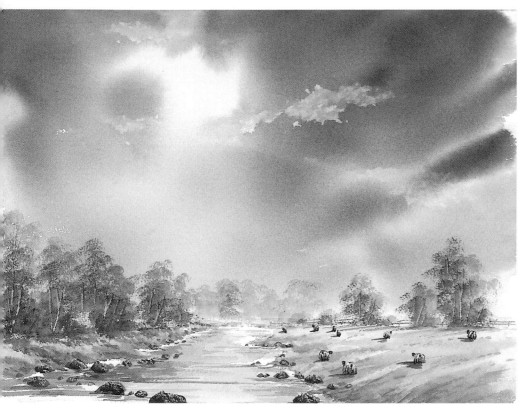

Evening Light. *You will enjoy this technique. I use it to produce large fresh skies. You must apply strong colours for your over-painting as they will weaken significantly when the paint runs and dries.*

TILTING BOARD

Interesting skies can be painted by applying a wet wash – in this case Raw Sienna – while this is still wet, adding stiffer colours; in this example these were Payne's Gray/Cerulean Blue on the right and Payne's Gray/Alizarin Crimson on the left.

I lifted the board and tilted it in different directions to allow the paint to blend. It takes experience and control to ensure the raw sienna is not completely covered; tilt to the left and, of course, both colours will run to the left, tilt to the right and both will run to the right. When I was happy with the result I laid the board flat again, blotted the sky area with a tissue to add a few white clouds and then allowed the sky to dry naturally.

BRUSHWORK

With this study I painted a weak Raw Sienna wash and, using the hake, brushed in various mixes of Payne's Gray/Cerulean Blue with Alizarin Crimson added to provide variation.

The brush strokes were the important factor in giving the sky the necessary atmosphere. I stroked, dabbed and turned the brush to achieve the desired effect. An absorbent tissue was used to remove paint to represent the patches of white cloud.

The shafts of light were created by applying pressure with a wedge-shaped tissue from the mountain tops upwards.

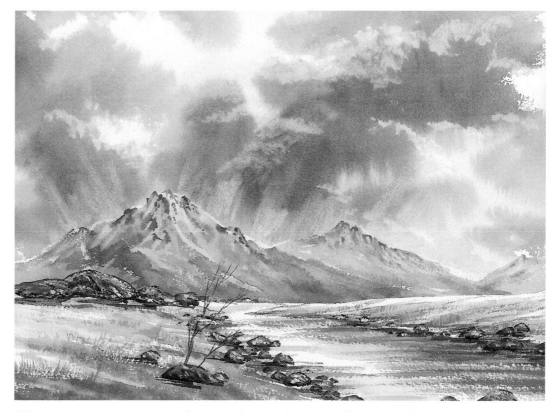

Winter Majesty *was painted very early on a freezing cold winter's day. The clouds seemed to be moving in several directions, with shafts of light dancing over the mountain tops.*

PAINTING MOUNTAINS *Introduction*

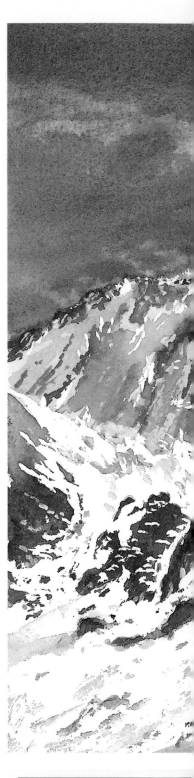

Mountain scenery has always held a great fascination for me. I can't resist painting snow-capped peaks rising upwards to the sky, and even large hills have me reaching for my sketch-pad. This sort of scenery doesn't have to be outside your window for you to paint it: you can do it from a picture you see in a book, magazine, or on television.

Time taken studying the structure of the mountain you are to paint will be well spent. Identify the main features such as distinctive gullies, fissures, promontories and peaks. You'll find a small pair of binoculars invaluable for picking them out. Whatever the characteristics of the mountain you are painting, always simplify its structure. It's not realistic to paint every snow-capped ledge or promontory. Don't forget that you're not trying to reproduce a photograph. Discard any detail that won't significantly contribute to the success of your painting. Concentrate on capturing its profile, its principal structural features,

the variations in colour and tone, the lights and darks. All these considerations will help you to create a believable representation.

Mountains are exciting and challenging to paint. Practise the techniques shown in the following pages and you will soon be able to paint realistic mountains.

You will call on a range of colours to paint mountains. Here are the ones I find most useful:

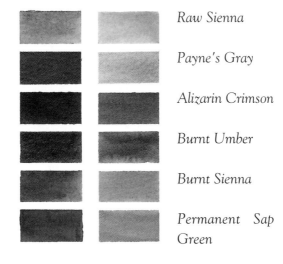

Raw Sienna

Payne's Gray

Alizarin Crimson

Burnt Umber

Burnt Sienna

Permanent Sap Green

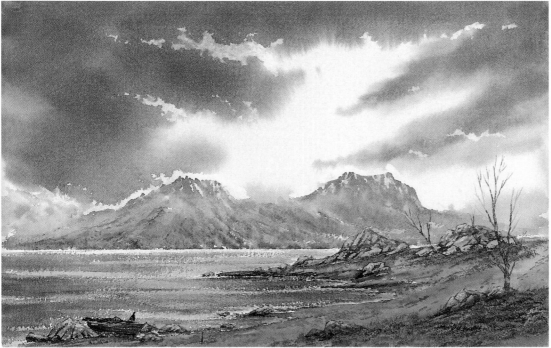

Going Fishing *is my vision of a Scottish loch. I used tissues to create the cloud formations and the distant mountain peaks, a palette knife for shaping the rocks, light strokes with the side of a round brush to paint the sparkle on the water, and stippling techniques for the heather and textures in the foreground.*

Check-List

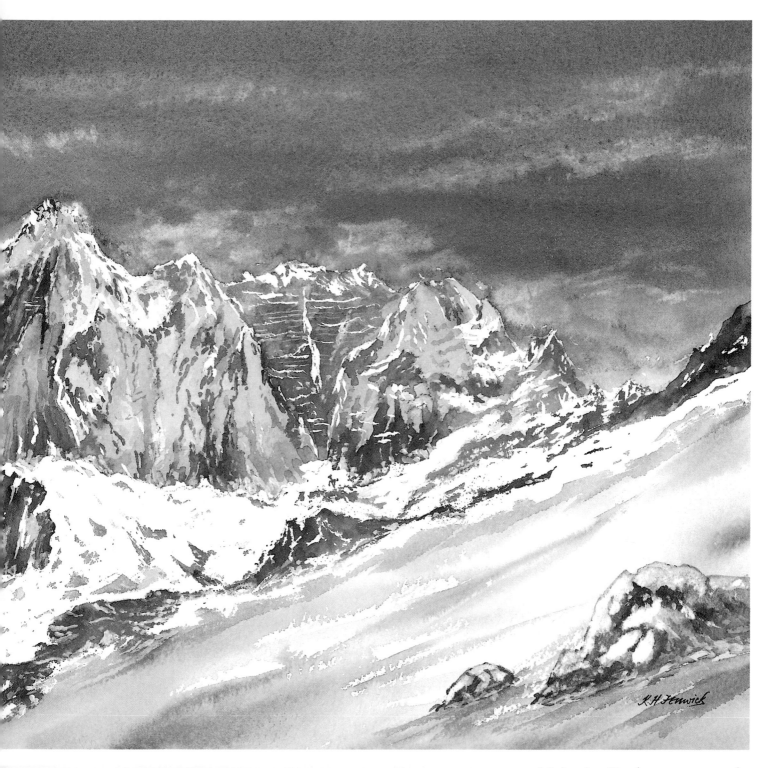

- Don't be too ambitious initially; choose a mountain that you feel lies within your compass of expertise.
- Study your subject closely, then simplify its structure, excluding unnecessary details.
- Observe the main colours and tones.
- Shape your mountain carefully, make it look real.
- Don't add details that aren't characteristic of the region you are painting.

Majestic Peaks represents the landscape in all its glory and yet also conveys a sense of awe. I have used many techniques here – tissues for the sky, masking in the mountains, the use of a palette knife to create structure and subtle touches of colour to enhance the landscape.

PAINTING MOUNTAINS *Using colour*

The colours you observe when studying your mountain will vary, depending on the time of day, weather conditions and the season. Changing light or passing clouds will alter the colours and tones. Attempt to retain an image in your mind and paint from that. It is not practical to keep changing your painting as time passes. Also, be aware that the colours become colder and lighter as the mountains recede into the distance.

My usual approach is to shape the mountain using a 1½in wash brush loaded with a weak Raw Sienna. While the paint is still wet I will brush in a variety of colours and tones to form the structure. As the paint dries, I brush in darker tones and shadows until I'm happy that I have created a believable representation.

To achieve the correct balance of colour you will need to experiment with mixing colours. The mixes shown right are just some of the variations possible using the colours shown below left.

The colours shown below right are mixes for mountain peaks and shadows, trees, grass, and varying strengths of Burnt Sienna for under-painting.

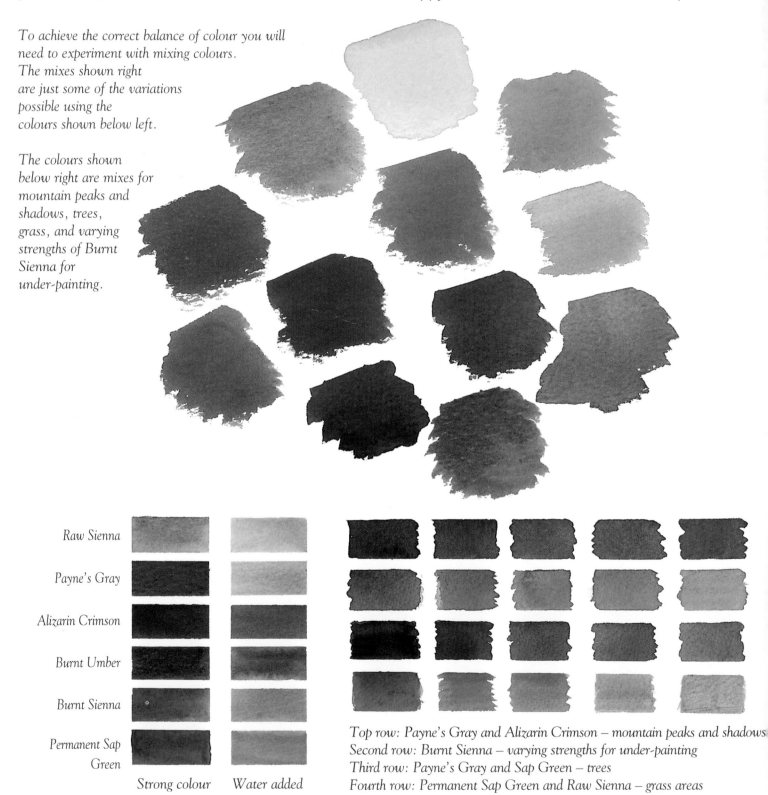

	Strong colour	Water added
Raw Sienna		
Payne's Gray		
Alizarin Crimson		
Burnt Umber		
Burnt Sienna		
Permanent Sap Green		

Top row: Payne's Gray and Alizarin Crimson – mountain peaks and shadows
Second row: Burnt Sienna – varying strengths for under-painting
Third row: Payne's Gray and Sap Green – trees
Fourth row: Permanent Sap Green and Raw Sienna – grass areas

BRUSH AND COLOUR EXERCISE

I encourage all my students to experiment with using a flat brush to apply paint.

Try it for yourself – you'll find the brush very versatile and capable of producing a wide variety of marks.

For this project I used a ¾in flat (Winsor & Newton Sceptre Gold II) and four colours (Payne's Gray, Alizarin Crimson, Raw Sienna and Permanent Sap Green). The flat brush is ideal for working around the peaks of the mountain as well as putting in the structure. I hold it at right angles to the paper, approximately 2in above the ferrule.

I took care to leave lots of white paper uncovered, to represent the snow. Mixes of Payne's Gray/Alizarin Crimson were also used.

The directional strokes used for the sky are in a Payne's Gray/Alizarin Crimson mix over a Raw Sienna wash.

The fir trees on the left were painted by adding Permanent Sap Green to the Payne's Gray/Alizarin Crimson mix and applying it with a rocking action to get a stippling effect. The trees in the distance were painted by applying the paint with a dabbing action.

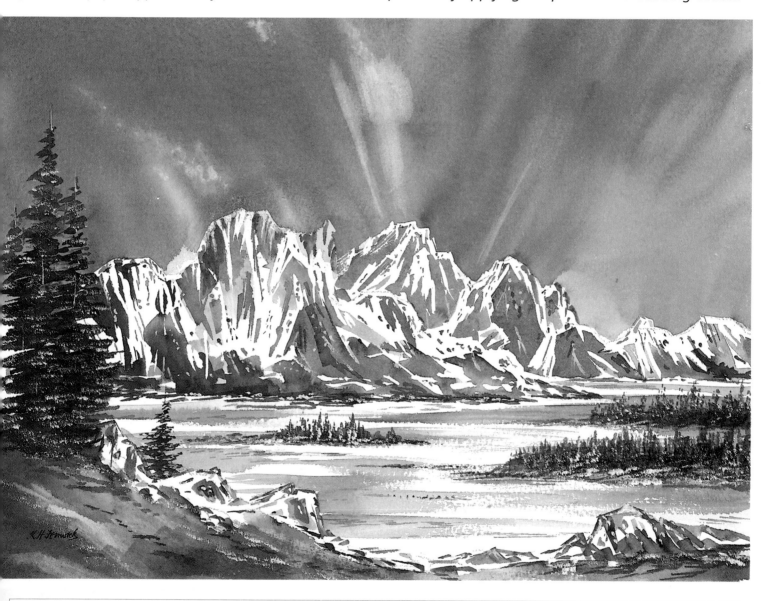

Photography

If you are simply making a sketch as a basis for a painting you will do at home, it can be useful to photograph the scene and use the print as reference.

Numerous techniques can be used to create mountain structures and features effectively. I find that the structure of the mountain will determine the techniques I use to paint it. In the next few pages I'll show you a variety of techniques that I use.

BRUSHWORK

*In **Peace and Tranquillity**, the soft realistic effect is achieved by initially painting a Raw Sienna wash and brushing in darker tones of various colours. Your brush strokes must follow the structure of the mountain. While the paint is still wet I use a damp size 6 brush to create structure.*

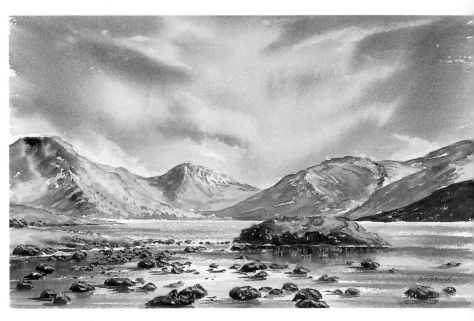

TRADITIONAL MASKING FLUID

*For **Room at the Top**, traditional masking fluid has been applied using a piece of grease-proof paper (plastic wrap or tissue are also worth trying). The grease-proof paper can be pressed to a rough shape for the larger areas or to a point for detail. I often use a cocktail stick dipped in masking fluid to give thin lines.*

Once the masking is dry, washes can be applied. I find gentle rubbing with a putty eraser the easiest way to remove the masking.

USING A PAPER WEDGE

*In **Pastures New**, I have painted the mountains using various colours and tones and created structure by removing some of the paint while it is still wet. This is done by making a tight wedge of tissue and wiping downwards from the top of the mountain. You'll need to continually form new wedges to ensure the paper does not become stained as the removed paint builds up on the tissue.*

If you use this method, ensure that you follow the shape of the promontories of the mountain, otherwise your painting will not look realistic.

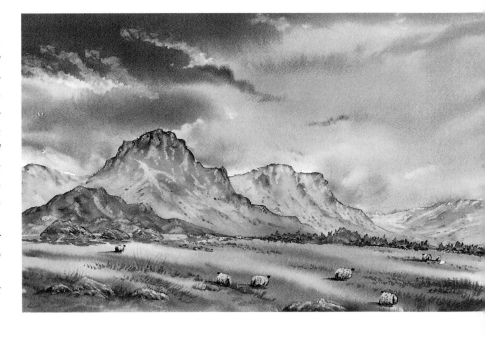

PALETTE KNIFE

Where Eagles Fly *is a good example of how a palette knife can be used effectively to create texture. I applied a wash of Raw Sienna and brushed in Burnt Sienna and Payne's Gray/Alizarin Crimson mixes. When the paint was no more than one-third dry, the texture was created by moving paint around with the palette knife.*

On the next spread we'll look in more detail at other effects that can be achieved with the painting knife.

PAINTING MOUNTAINS *Techniques: Creating realistic effects*

As we have already seen, the brush is not the only means by which you can achieve realistic effects in your painting. Indeed in some instances you will find the knife is better able to give you the effect you are after.

Most artists are familiar with the use of a knife for oil painting, where it is used to pick up paint and apply it to the canvas. The method of working when using the knife for watercolour painting is somewhat different but very simple.

First, I paint the shapes with a traditional brush. If you apply the knife when the watercolour wash is very wet, the paint is easily moved and the white of the paper is restored. A pleasing dark shadow will result at the base of each stroke.

All types of stonework – such as buildings, mountains, stone walls, cliffs and rocks – can be quickly and realistically painted by applying several colour washes, and when approximately one-third dry applying the knife to create specific effects. Experimenting with different drying times will enable you to achieve a variety of tonal values. This can be particularly useful when you are painting features such as rocks.

This scene, which I call **Wild Water***, was painted with a knife. Short strokes were used to form the mountains in the distance, while sweeping strokes were required for the boulders in the middle distance and foreground.*

Working with a knife

The effects that can be achieved with the knife are not so effectively produced with a brush.

CLIFFS AND ROCKS

The tip of the knife can be used to create thin lines and the side of the knife to create rocks, promontories or cliffs of different sizes.

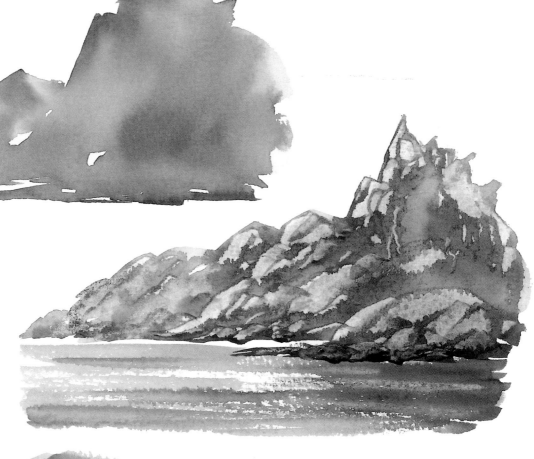

I often paint darker shadows underneath foreground rocks to create recession in the painting, as in this example. I used Raw Sienna for the underpainting. Burnt Sienna and a Payne's Gray/Alizarin Crimson mix provided the darker tones.

TEXTURED ROCK SURFACES

This kind of effect is easily achieved and can be used in a variety of situations – for example, to represent a river bank or perhaps the slightly raised surface at the top of a waterfall where the rocks may only protrude a few inches. The shadows can be painted in darker tones.

The effect in the top painting was achieved simply by means of a palette knife. A different kind of texture can be achieved with permanent masking fluid, as seen in the painting below.

This group of rocks was painted by initially applying permanent masking fluid with a little Raw Sienna and when dry, over-painting this with various washes. The permanent masking repels the watercolour to create a textured effect. Unlike traditional masking fluid (see page 30), permanent masking fluid is left on the paper.

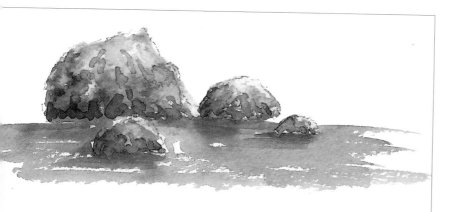

PAINTING MOUNTAINS *Close up*

To establish the best vantage point for your composition, complete a quick tonal sketch using a dark brown water-soluble crayon, then compare it with the shape, structure and tonal variations of the scene in front of you.

You can continue modifying the sketch until you're happy that you've achieved an acceptable representation. You'll find this exercise very helpful when you come to apply paint to paper. The beauty of the crayon is that any marks wash out as the painting progresses.

The most time-consuming part of this painting was drawing the outline with the dark brown water-soluble crayon and applying the masking fluid. The drawing and masking were done prior to the sky being painted.

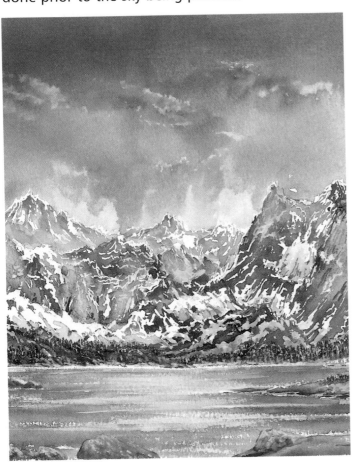

SKY AND WATER

I felt I needed an atmospheric but not too overpowering sky for this painting, because there was lots of detail in the structure of the mountain range. I applied a very weak Raw Sienna wash to wet the paper and brushed in mixes of Payne's Gray/Cerulean Blue/Indanthrene Blue with the 1½in washbrush (hake). Patches of white cloud were created by using an absorbent tissue to remove the paint.

The colours for the sky were also echoed in the water of the lake. For this, I used the side of a size 14 round brush, taking care to ensure the brush strokes were perfectly level. A light touch of the brush left some of the white paper showing through, representing sparkle on the water. Think of the texture of your paper as representing mountains and valleys. If you move your brush quickly and lightly across the paper you will deposit paint on the peaks of the paper only, leaving the valleys (the white of the paper) uncovered.

TREES

The fir trees were painted using a technique I developed many years ago. I position a piece of ³⁄₄in masking tape on the paper to represent the base of the trees, then I take a size 6 rigger brush loaded with paint (in this case Permanent Sap Green), hold it out in front of me, with my hand almost flat to the paper, and dab away at the paper. The shape of the brush ensures that distant trees look realistic. The rock was included to help balance the painting.

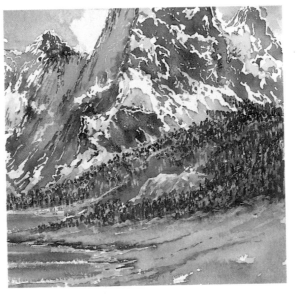

Think simple

I produced this painting **Wilderness** *– from my imagination after reading a series of books by a wonderful American author, David Thompson. It might look complex, but it's really quite simple. Think of it as a jigsaw with each part of the painting representing a piece of the jigsaw. For example, the mountain range can be broken down into several pieces, each one painted separately*

34

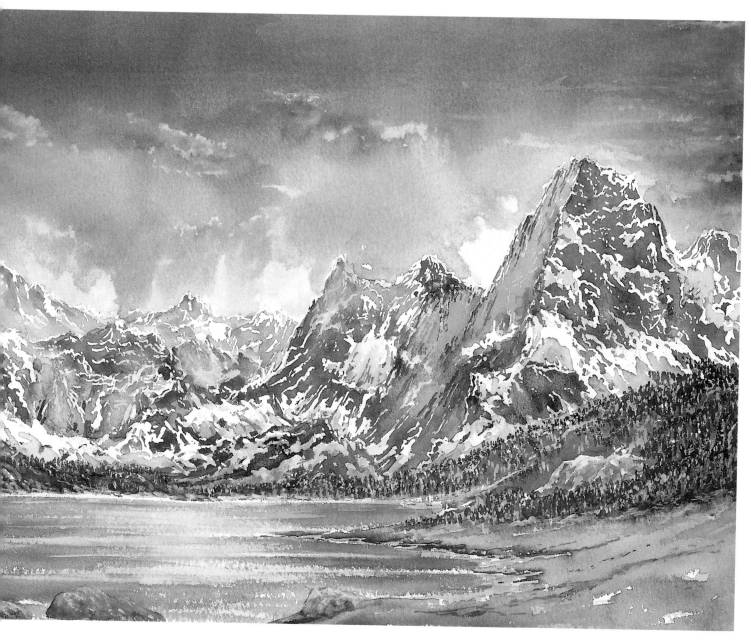

?OUNTAINS

?ce the sky was painted, Raw Sienna and Raw
?nna/Burnt Sienna washes were applied to
?ate light and dark areas in the mountains. A
?ne's Gray/Alizarin Crimson mix was added to
?nt the shadows in the mountains. Never use
?ck for shadows; it kills a painting.

?Once dry, remove the masking using a putty
?ser and add a Cerulean Blue wash to selected
?as of the snow, to represent cloud shadows.

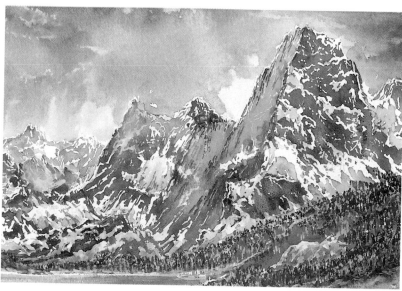

PAINTING MOUNTAINS *Project*

My students enjoy painting **Walk on the Beach**, a coastal scene at evening. The techniques used to paint the cliffs and the rocks on the beach are exactly the same ones I would use for painting mountains.

No initial drawing was done for this project. Instead I positioned a piece of ³⁄₄in masking tape horizontally, approximately one third up the painting. The top of the masking tape represents the horizon or water-line.

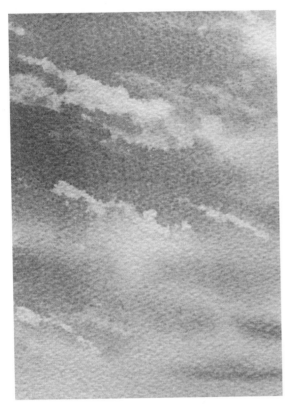

1. THE SKY

I began with the sky, applying a Raw Sienna wash and, while this was still wet, brushing in Cerulean Blue and splashes of Alizarin Crimson. When the shine had gone off the surface and the wash was approximately one-third dry, the clouds were painted with a Payne's Gray/Alizarin Crimson mix.

Finally, I removed paint with an absorbent tissue to represent cloud structures. The sky was allowed to dry completely.

2. CLIFFS AND ROCKS

The next stage is to paint the distant cliffs in a light tone to achieve recession, darker tones being added as the cliffs become closer. For these, I used a Raw Sienna under-painting with splashes of Burnt Sienna and a Payne's Gray/Alizarin Crimson mix.

When the paint was one-third dry I used a palette knife to move the paint to create the rocky appearance. The paint was dried using a hairdryer and then the masking tape slowly removed.

The same process was used to complete the cliffs on the right of the painting, adding darker tones to the nearest rock grouping.

A smaller, darker group of rocks was added on the left to balance the painting. It always amazes me how realistic-looking rocks can be created: simply by brushing on three colours and moving them around with a palette knife (see page 33).

The sea was painted using a 1½in wash brush loaded with a soft blue mix. To create the effect of distant waves, I moved the brush in horizontal lines, depositing paint every 1½ inches (the width of the brush).

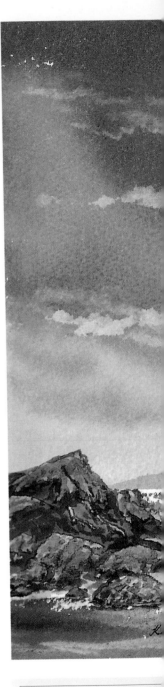

These are the colours you will need

Payne's Gray | Cerulean Blu(e)

Alizarin Crimson | Raw Sienna

Burnt Sienna

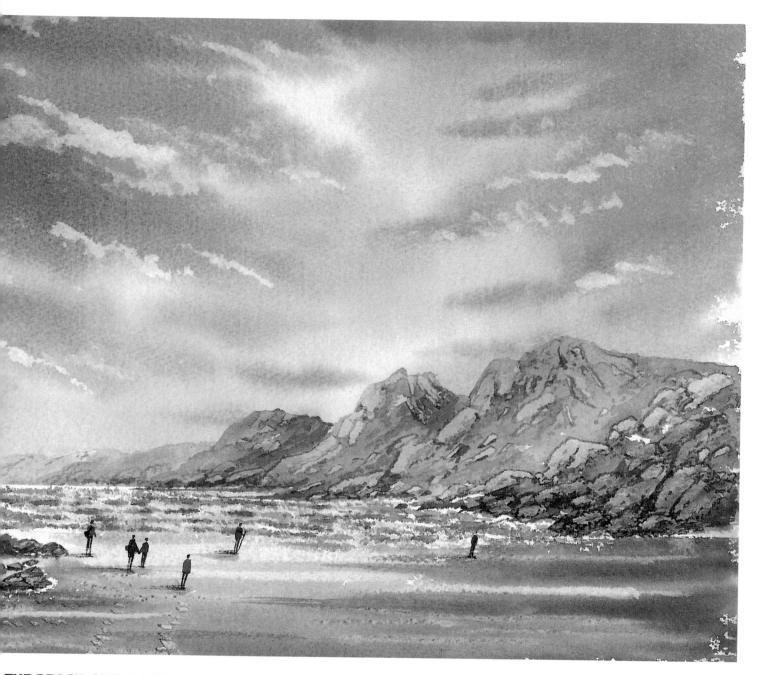

THE BEACH AND ADDING THE FIGURES

e beach was painted using horizontal strokes with
1¹/₂ in hake brush. The same colours as for the sky
re applied – lighter colours in the distance, darker
ones in the foreground. Once dry, the figures were
added. Don't forget to add shadows under the
figures. I even scratched in a few footprints with the
palette knife for realism.

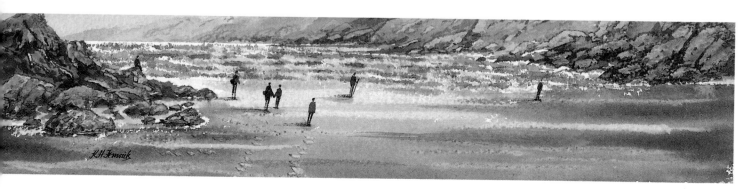

PAINTING MOUNTAINS *Tonal values*

All successful artists appreciate the importance of establishing the lights and darks in their paintings, arranged in relationships that enhance the quality of their work. All paintings need these contrasts, and I don't believe it's possible to produce a good landscape without the careful distribution of tonal values.

It's a common misconception to think that painting is principally about splashing paint on. It's not. When I look at my students' work, in eight cases out of ten I find their paintings lack depth. This is because they don't give enough thought to tonal values. Before you start a painting, I recommend you always produce simple tonal study to clarify your thinking.

A tonal study is a simple sketch produced in a few minutes to establish the lights and darks in a painting. I complete these to a size of about 3 x 4½ inches using a dark brown water-soluble crayon.

You can find out whether you have passed the tonal values test by taking a black and white photocopy of your completed full colour painting and comparing with the original. If the tones appear to be the same all over, you'll know you haven't passed it.

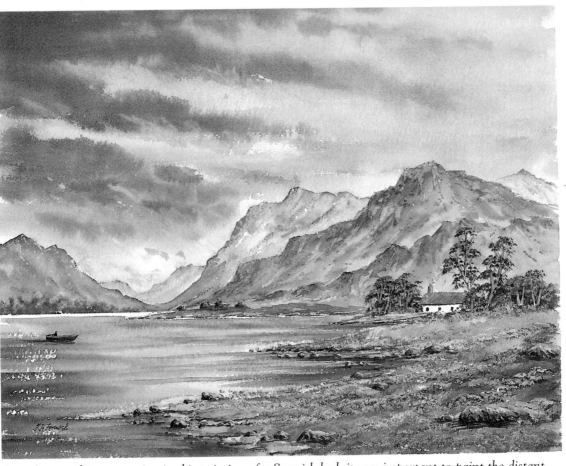

In order to achieve recession in this painting of a Scottish loch it was important to paint the distant mountains lighter in tone.

EXERCISES

1. Practise using masking fluid to create snow-capped mountains. Apply the fluid with the use of crumpled grease-proof paper. Use slivers of card dipped in masking for thin lines, cutting off the end after each application to ensure you maintain the thinness. This saves cleaning the brushes.

2. Experiment with a painting knife – you will be amazed at what you can achieve.

3. Practise applying a wash. While the wash is still wet, drop in other colours, allow them to fuse together and move the paint about with a damp brush to create the effect you're looking for.

How to transfer an outline drawing of a completed painting onto watercolour paper

The next technique is not a substitute for learning to draw and should only be used until you are competent at drawing.

1. Take a black and white photocopy of the painting to the size required.

2. Using a soft pencil (6B), scribble across the back of the photocopy.

3. Position the photocopy over your watercolour paper, trace around the outline and key features using a biro or 2H pencil.

4. Remove the photocopy. The image will have transferred to your paper ready for you to apply paint.

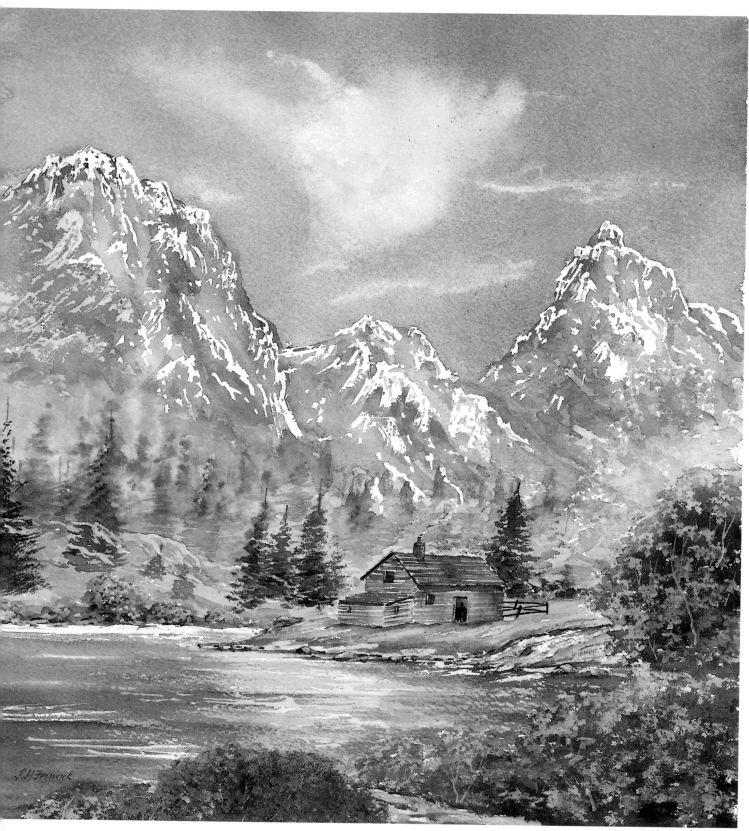

this painting, called **Sunburst**, I applied masking to the untains and allowed it to dry completely. I painted a circle of v Sienna in the sky area and poured pre-mixed washes onto it – rulean Blue on the left and Cerulean Blue/Alizarin Crimson on right. I angled the paper until it was almost vertical and then tilted it to encourage the colours to run together, flow down over the mountains and run off the bottom edge of the paper. I painted darker tones into selected areas in the mountains. Finally the paper was laid flat and allowed to dry completely. The masking was removed to reveal the white of the paper, representing snow on the mountains.

39

PAINTING LAKE SCENES *Introduction*

Water lends itself ideally to watercolour techniques. Water comes in three types: motionless, as in a puddle in a country lane, a still pond or a calm lake; moving water, as in a slow-moving river, a wind blown lake or a harbour; and turbulent, such as a waterfall, seascape or fast-flowing river.

In this section we will be concentrating on painting lake scenes. Water itself has no colour, it reflects elements around it such as a mountain range, a building or tree, but in the main it is the colours of the sky, a blue, grey, or brown cloud formation that gives the water its colour. A sunset reflected is a beautiful sight.

When you observe a still lake, the rocks, trees, banks and other surrounding objects reflect as a mirror image. It only takes a slight breeze to ruffle the water and the colours change significantly.

You will call upon various colours to paint lakes. Below right are the ones I find most useful.

When painting lakes always bear in mind the following points:
• *Water and reflections are continually shifting, depending on the weather. Don't try to change your painting as the conditions change. Form an initial impression in your mind and paint from that.*
• *Water has no colour; its surface reflects sky and objects around it.*
• *Use the largest brushes possible and apply horizontal brush strokes – water doesn't flow uphill.*
• *Reflections are best painted wet into wet, so paint your water in last, once the reflecting objects have been painted.*
• *Light objects usually reflect darker, dark objects lighter.*
• *To achieve recession in a painting, paint the water lighter in tone near the horizon and darker as it approaches the foreground.*
• *Don't confuse reflections with shadows. Reflections will always be a near vertical mirror image of the reflecting object. The direction of the shadows will depend on the source of light.*
• *The angle of a reflecting object will be opposite in angle to the reflecting object. A tree trunk at an angle is a good example. The reflection will be vertically below the tree but reflected in the water at the opposite angle.*

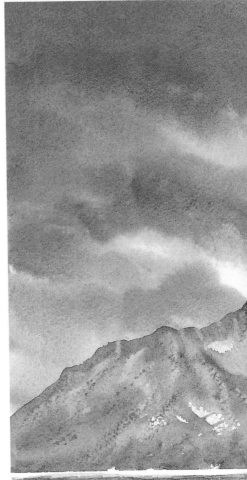

French Ultramarine

Payne's Gray

Alizarin Crimson

Burnt Umber

Cerulean Blue

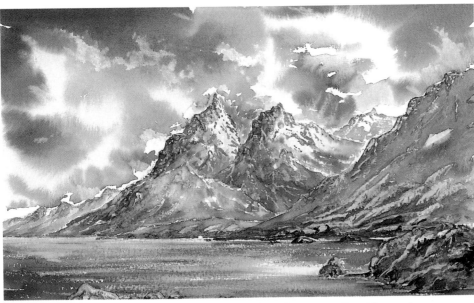

In **Snow Capped** *the sky colours were reflected in the water. Sparkle on the water was achieved by moving the brush lightly and quickly across the paper. The atmospheric sky is a feature in this sketch. The foreground rocks were created with a palette knife.*

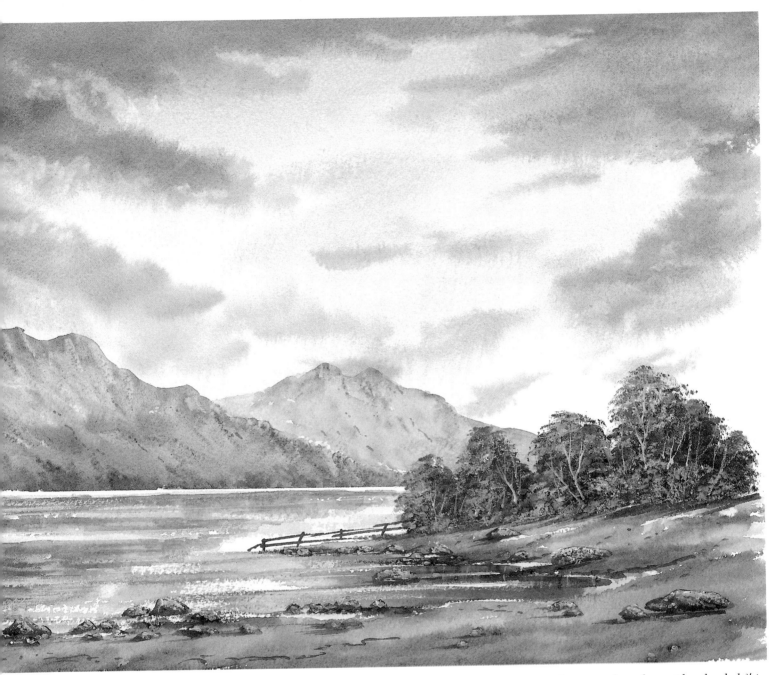

Autumn on the Loch. *The reflections were painted as a mirror image of the mountains, using downward strokes with a loaded ³/₄in flat brush. A white water-soluble crayon softened in water was used to indicate wind lines across the loch.*

Basic considerations when painting a lake scene

In the distance you will see a white or pale-coloured line where the light shimmers across the water as it meets the land. Water in a lake is always level, so it's important that your brush strokes take this into account. I have seen so many amateur paintings where the brush strokes haven't been horizontal, giving the impression of the water running downhill.

Recession: This is accomplished by painting distant objects in pale tones and foreground objects in darker tones.

Reflections: For best results use downward strokes with a flat brush, following a mirror image of the reflecting object. Note that the mirror image must be measured from the base of the reflecting object, which may not come down to the water's edge.

PAINTING LAKE SCENES *Using colour*

It's not a good idea to have too many colours, because you'll only end up totally confused as to which ones to use. Problems in colour mixing usually result from using a paint box full of tiny pans of colour. If you've got a multitude of pans, they soon become dirty and muddy and frustration quickly follows.

A modest selection of eight colours, plus any special colours you feel you need, is sensible. I prefer tube to pan colours because I like to start each painting with soft, fresh colour. I also like to use a large mixing area which allows me

to maintain more space between colours. I always lay the tube colours out in a logical sequence – sky colours, earth colours, mixers.

I mainly use two colour mixes for painting water: Payne's Gray/Cerulean Blue; Payne's Gray/French Ultramarine. I often add a little Alizarin Crimson to brighten the colour mix or a little Burnt Umber to darken the mix. You will produce a wide range of shadow colours if you add 20 per cent of any colour on your palette to 80 per cent Payne's Gray. Don't use black for shadows – it deadens a painting.

To achieve the correct balance of colour you will need to experiment with mixing colours. The mixes shown right are just some of the variations possible using the colours shown below left.

The colours shown below right are mixes for water.

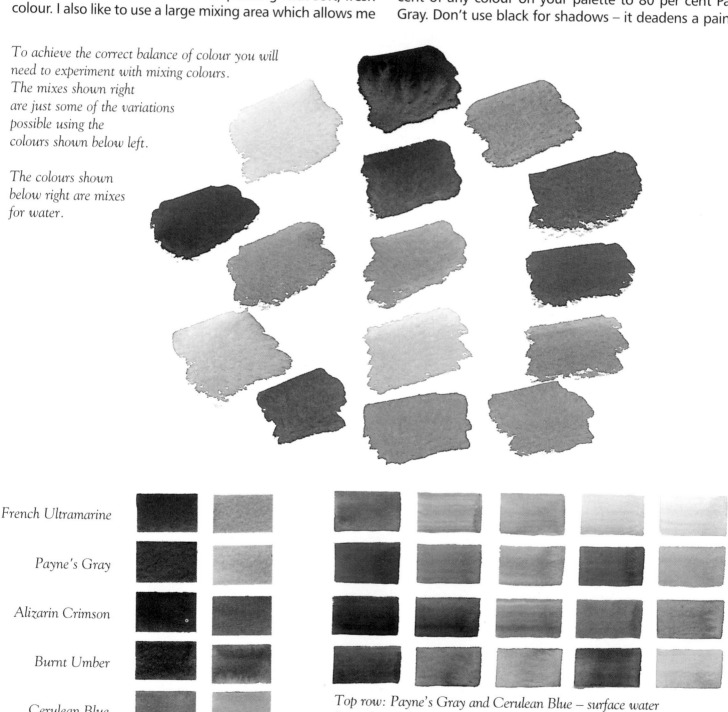

French Ultramarine

Payne's Gray

Alizarin Crimson

Burnt Umber

Cerulean Blue

Strong colour Water added

Top row: Payne's Gray and Cerulean Blue – surface water
Second row: Payne's Gray and French Ultramarine – surface water
Third row: Payne's Gray and Alizarin Crimson – for pale shadows
Fourth row: Payne's Gray and Burnt Umber – for dark shadows

BRUSHWORK

Let's now concentrate on the actual brushwork used to paint water. I want you to think of your paper texture as mountains and valleys. If you move a loaded brush slowly across the paper, the paint will cover the peaks and run down into the valleys, creating a solid mass of colour we know as a wash. If we move the brush quickly across the paper with a light touch the paint will be deposited on the peaks only and will not have time to run down into the valleys. The result will be broken colour representing sparkle on the water.

PROJECTS

1. Purchase a small watercolour pad and practise your colour mixing.
2. Paint a tree above the river bank and practise wet into wet reflections.
3. Practise creating sparkle on the water by moving the brush quickly across the surface of the paper using a light touch at the end of your strokes.
4. Practise mixing a range of shadow colours by mixing 20 per cent of any colour on your palette with 80 per cent Payne's Gray and adding various amounts of water to create lighter tones.

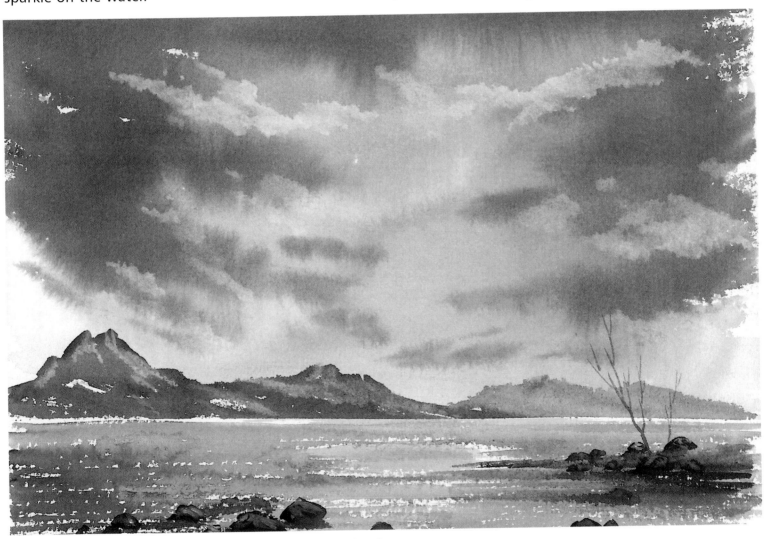

In this evening sketch, notice how the sky colours are reflected in the water.

Tonal balance

It is a good idea when painting water to use similar colours and tones as those used for the sky. This provides a nice tonal balance for the painting.

PAINTING LAKE SCENES *Project*

Grand Teton National Park in Wyoming offers a breath-taking range of jagged peaks which appear to rise out of Jackson Lake to heights above 13,000 feet. The area is noted for its intense blue skies and these contrast sharply with the snow-capped peaks. The reflection of the mountains in the clear water of Jackson Lake is the subject of this stage-by-stage project, which I've called **Evening in the Tetons**.

1. THE OUTLINE DRAWING AND THE SKY

I positioned ³⁄₄ in masking tape across the paper approximately one-third of the way up the painting to represent the water-line. The profile of the mountains was drawn using a dark brown water-soluble crayon.

I used a mixture of French Ultramarine/Payne's Gray, applied with a 1¹⁄₂ in wash brush (hake) to paint the sky. Subtle touches of Alizarin Crimson were added to selected areas. A soft absorbent tissue folded to a wedge shape was used to remove colour by dabbing the paper, to create the white clouds.

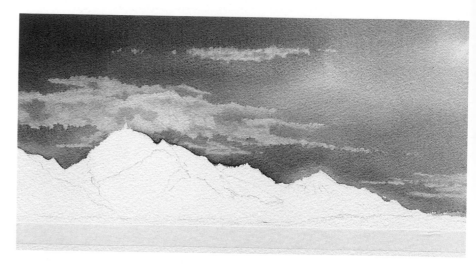

2. THE MOUNTAINS

The basic structure of the mountain was painted with a pale wash of Payne's Gray with darker tones applied to the peaks and selected areas. The white of the paper was left uncovered to represent the snow. While the paint was still wet, I used a tissue shaped to a wedge to soften the edges. A size 6 round brush was used to add detail.

Various mixtures of Payne's Gray/Burnt Umber/Permanent Sap Green and Payne's Gray/Alizarin Crimson were used to apply directional strokes with the side of a size 14 round brush upwards from the tape.

I finished by adding a few fir trees at the water's edge, using the size 6 brush loaded with Permanent Sap Green. The masking tape was carefully removed.

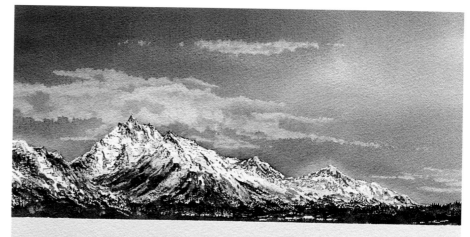

3. THE WATER

We now come to the painting of the water. Initially I used a 1¹⁄₂ in wash brush loaded with the sky colours. I kept my brush strokes precisely horizontal to ensure that the water looked level.

When the paint was one-third dry I painted the reflections, using downward strokes with a 1in flat brush. I used the colours of the sky to paint the mountains, ensuring that the reflections were a mirror image of the mountain range. I used a tissue to remove paint to indicate reflections from the snow.

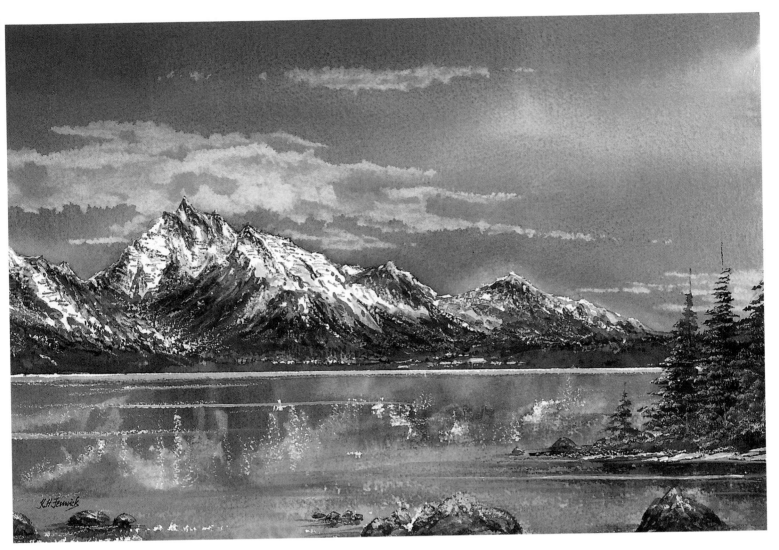

4. ADDING DETAILS AND FINISHING TOUCHES

Using a ¾ in flat brush, I balanced the painting by adding the land area and fir trees (Permanent Sap Green/Payne's Gray mix), and positioning a few rocks.

To finish the painting, I dipped a white water-soluble crayon in water and allowed it to soften before applying it to the fir trees and to the tops of the rocks in the foreground, to represent snow. I applied a few upward strokes of the softened crayon to the surface of the lake, too, to add sparkle to the reflections. Horizontal strokes with the crayon represented wind lines on the surface of the water.

To complete the water, I painted the right-hand side with a little weak Alizarin Crimson to represent reflections from the sky.

These are the colours you will need

Payne's Gray

Alizarin Crimson

Peranent Sap Green

French Ultramarine

Burnt Umber

45

SKIES, MOUNTAINS and LAKES *Practice*

In this final spread I want you to practise the three principal elements that are the subjects of this book in one watercolour painting: skies, mountains and lakes. The scene I have chosen for this exercise is typical of the Scottish highlands, with a tranquil loch overlooked by a traditional croft, a majestic mountain in the background and a spread of sparkling water. The principal design considerations in this painting are the need for recession and the importance of balance between the elements.

As always, build up your painting. Begin by preparing an outline drawing, then position a piece of masking tape across the paper to represent the horizon or water level. Now, follow my instructions to complete the painting.

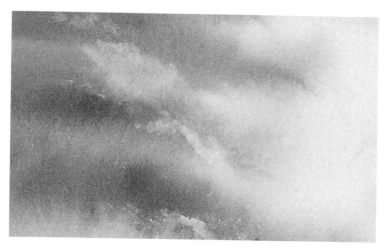

THE SKY

As we have seen, the sky establishes atmosphere and mood, and takes up almost two-thirds of a painting. A fresh wet into wet sky is required here, with cool darker clouds painted in on the left to balance the warm colours of the croft. The mixture for the cloud structures was produced with Payne's Gray and the addition of a little Cerulean Blue and Alizarin Crimson over a Raw Sienna under-painting. A soft absorbent tissue was used to remove some of the colour to shape the cloud formations and soften their edges.

THE MOUNTAINS

For the sake of realism it is important that your brush strokes follow the structure of the mountain. After initially applying a Raw Sienna wash, I used a Payne's Gray/Cerulean Blue mix for the peaks of the mountains in the foreground. Then I used a tissue pressed to a wedge (see page 30 for technique) to remove paint and create the features of the mountains.

A Permanent Sap Green/Payne's Gray mixture applied with a dabbing action was used for the impression of trees at the foot of the mountains.

To achieve recession, the distant mountain was painted in light tones of a mixture of Payne's Gray/Alizarin Crimson. Then I used a tissue to soften the structure, enhancing the illusion of recession.

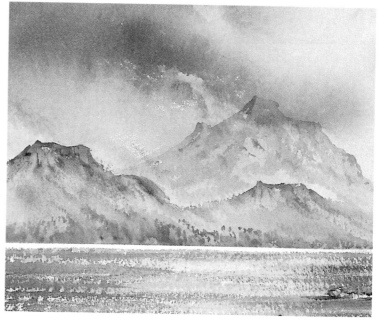

THE LAKE

In order to create sparkle on the water, move your loaded brush quickly and lightly across the surface of the paper. This will leave some of the white of the paper uncovered to represent light on the water. The boat is important compositionally and was added to balance the building diagonally.

The colours used were a mixture of Payne's Gray/Cerulean Blue/Alizarin Crimson. When these were dry, I applied a pale wash of Raw Sienna to selected areas.

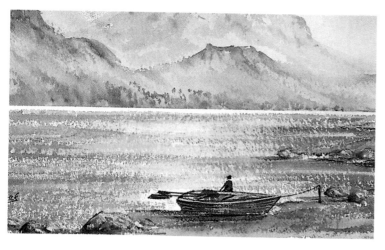

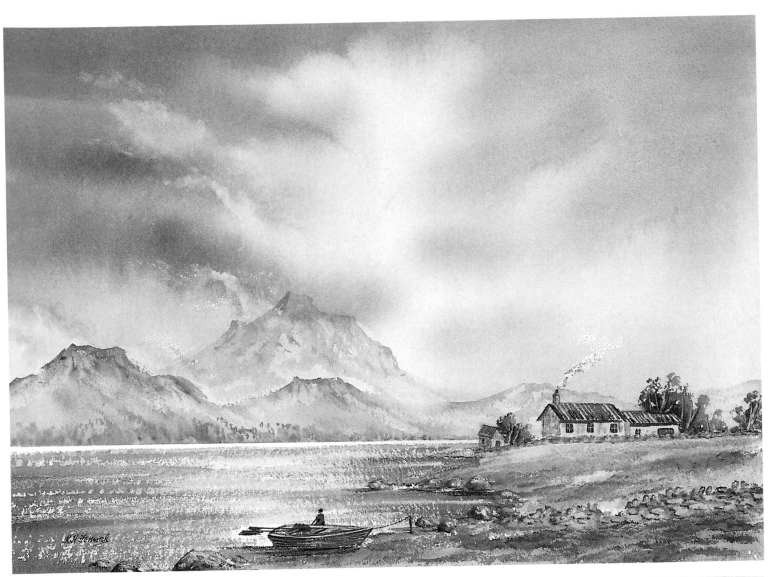

BUILDINGS AND FOREGROUND

The roof of the croft adds warmth to the painting. It was painted with a mixture of 20 per cent Alizarin Crimson and 80 per cent Burnt Sienna. The smoke was achieved by painting a little white over a Payne's Gray underpainting.

The foreground was painted by applying several washes of green made from mixes of Permanent Sap Green and Raw Sienna. Payne's Gray was added to the mixture to darken the green in the near foreground.

The rocks and stone wall were added using mixes of Raw Sienna and Burnt Umber. While the paint was still wet, a tissue was used to remove paint from the tops of the rocks to represent light reflecting off them.

Levelling the water-line

When painting mountains that fall down to the water's edge, I position a piece of masking tape across the paper, representing the water line and paint my mountains down to the tape. If the paint goes over the tape slightly, it doesn't matter. When the paint is dry, I carefully remove the tape. The water-line will appear perfectly level – a useful technique.

PORTRAIT OF THE ARTIST

Keith Fenwick is one of the UK's leading teachers of painting techniques. He enjoys a tremendous following among leisure painters, who flock to his demonstrations and workshops at major fine art and craft shows.

Keith is a Chartered Engineer, a Fellow of the Royal Society of Arts, an Advisory Panel member of the Society for All Artists and holds several professional qualifications including an honours degree. He served an engineering apprenticeship, becoming chief draughtsman, before progressing to senior management in both industry and further education. He took early retirement from his position as Associate Principal/Director of Sites and Publicity at one of the UK's largest colleges of further education in order to devote more time to his great love, landscape painting.

Keith's paintings are in collections in the United Kingdom and other European countries, as well as in the United States, Canada, New Zealand, Australia, Japan and the Middle East.

Keith runs painting holidays in the UK and Europe, seminars and workshops nationwide and demonstrates to up to 50 art societies each year. Keith can be seen demonstrating painting techniques at most major fine art and craft shows in the UK. He has had a long and fruitful association with Winsor & Newton, for whom he is a principal demonstrator.

Keith's expertise in landscape painting, his writings, teaching, video-making and broadcasting ensure an understanding of student needs. His book *Seasonal Landscapes* has proved very popular, as have his 20 best-selling art teaching videos, which have benefited students worldwide. He is a regular contributor to art and craft magazines.

Keith finds great satisfaction in encouraging those who have always wanted to paint but lack the confidence to have a go, as well as helping more experienced painters to develop their skills further. He hopes this series will be a constant companion to those wishing to improve their skills and experiment with new ways to paint the landscape.